# My Time To Color

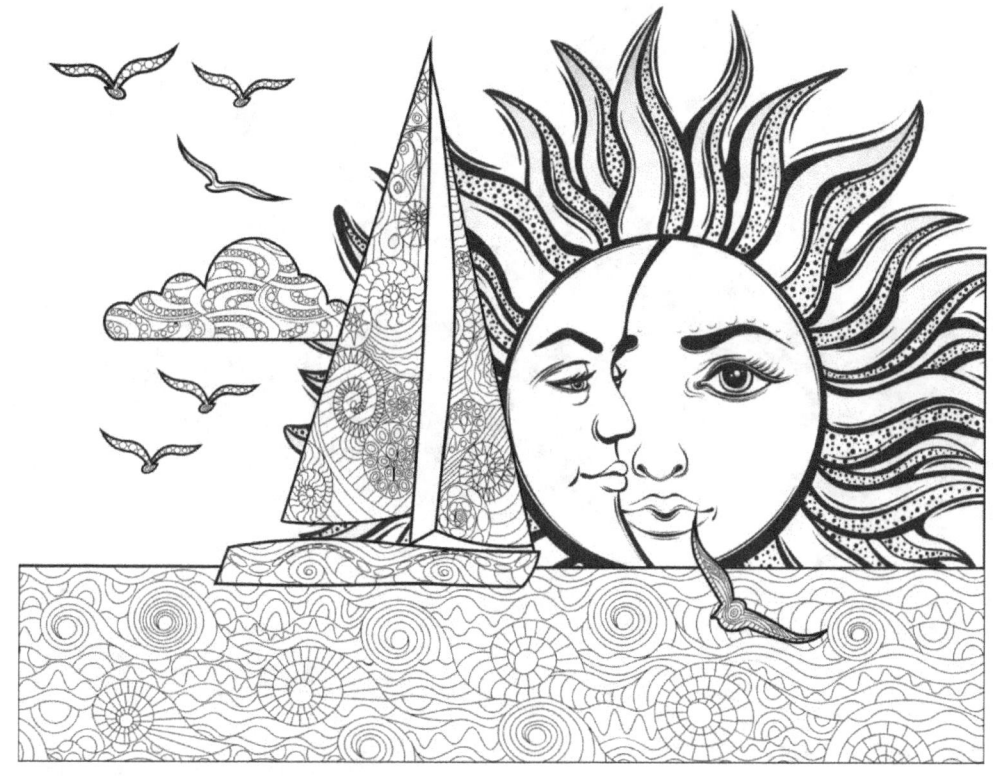

# My Maryland

Coloring Book

Copyright 2017 –

Swift Publishing/MyTimeToColor.com

All Rights Reserved

Images May Not Be Replicated or Reproduced

Some design elements/images used under license from Shutterstock.

ISBN-13: 978-1544806174

ISBN-10: 1544806175

# SHOW US YOUR ART

Let others see your beautiful creations! We love seeing your completed coloring projects from this book and sharing them! It's so exciting!

Please submit a picture of your completed art work via:

Facebook:

http://Facebook.com/mytimetocolor

Website:

http://MyTimeToColor.com/myart

Email:

myart@mytimetocolor.com

# FEEDBACK

We appreciate you and look forward to receiving any feedback or requests you have.

You may reach us through:

Facebook:

http://Facebook.com/mytimetocolor

Website:

http://MyTimeToColor.com/feedback

Email:

feedback@mytimetocolor.com

Amazon:

Please take a moment to post a review!

# INTRODUCTION

Adult coloring books are all the buzz of late. It is clear that it revolves around colored pencils or crayons and coloring pages. But, it is just coloring, right? How can something like staying within the lines be a benefit to me?

As kids we could spend hours coloring in all kinds of pictures. Little did we know then that coloring pages were a benefit to our well-being too.

Well, apparently they were back then and still are today for people of all ages.

People are making adult coloring books bestsellers on Amazon! At the time of this writing, a quarter of the top books on the bestsellers list are coloring books for adults. There must be something behind this recent growth in interest.

Adult coloring books are, very simply, books filled with illustrations designed to be filled in with colored pencils, markers, crayons, or whatever other media you wish to use.

The themes of adult coloring books are usually more detailed than children's books. Some are intricate. They are centered more around adult images like geometric designs, repetitive 'wallpaper' type patterns, cities and buildings, elements of the natural world, mandalas, and celtic designs, not your childhood counterparts that included bunnies, super heroes, and farm animals.

So why the fascination, and how can they help you?

In the most basic sense, the act of applying colored media to line drawings is a benefit to relaxation and stress reduction. You are able to put the outside world aside for the moment and focus on the art of coloring.

Studies have shown that anxiety levels dropped in adults that colored. The focus on coloring and switching off the brain allows that blocking of anxiety in the moment. Similar to listening to calming music, coloring does not have a need for complicated

thought processes, allowing you to get within yourself, isolated from external anxiety, commotion, and distractions.

The repetitive, low-stress act of coloring lends itself to relaxation. The calming effect not only helps to reduce stress levels, but also can help to connect you back to your youth.

The awesome part is that anyone can do it with no skill set required! Grab a colored pencil and you are good to go.

It can be enjoyable to have your kids or grandkids color with you. Depending on the age of the young ones they may be interested in the adult coloring books, others may still want to color a cow, astronaut, or pretty flower arrangement.

So what's all that fuss about? Why is coloring suddenly so trendy?

Well, apparently:

**It gives you permission to feel like a child again.**

Adult coloring books can bring about an air of mystery and intrigue, promising new, unknown and undiscovered adventures. More and more grown-ups are into this and it's no coincidence. Coloring is proven to evoke your inner child who simply wants to play and feel good. No more, no less.

You enjoy recapturing the nostalgia of childhood by engaging in an activity usually reserved for children. It takes people back to a simpler time, and can also be a way for parents to connect and bond with their children by sitting down to color with them.

**It gives you the unique chance to escape from reality.**

"Escapism" is defined as "entertainment or recreation, as an "escape" from the perceived unpleasant, boring, arduous, scary, or banal aspects of daily life." In other words - coloring helps you cope with the otherwise stressful or awfully boring routine or even in some cases, with depression. The magical world of multiple shapes and colors takes you to a far nicer place, where you could enjoy simple pleasures.

**It sets your inner muse free.**

You can't paint? Well, you can always color! Many people have the same problem - they're full of creative energy but are unable to scribble a doodle. And it can make you feel bad sometimes, when you have creative energy and don't know what to do with it.

With coloring books it's easy to set your creativity free to make your own unique picture.

**It's actually healthy.**

Mental health is often neglected but just as important as your physical wellbeing. And coloring has a soothing effect both on body and soul. It helps you relax and free yourself from the clutches of stress.

The back and forth movement of the crayon, colored pencil, or marker does in fact have a calming effect since it requires the use of both sides of the brain causing neurons to reinforce their connections between both sides while shutting down the frontal lobe which controls organization. So, after a stressful day a feeling of balance can be brought back by coloring. It gives relief to the daily demands of focusing at work, stress of everyday life, information overload, intense competition, intense play, intense everything at times.

**It helps you socialize.**

Throw a coloring book party, inviting your childhood best friends! Everyone gets a copy and loosens their imagination over a cup of coffee or wine. You could talk about the good old times or simply discuss your favorite TV shows.

There are Meetups for coloring. Libraries are offering coloring groups and there are other social events for people who enjoy coloring.

**It gives you a reality check.**

First and foremost, it allows you to touch paper. And paper, as it turns out, is missing more and more from our daily lives, being replaced with all kinds of tech gadgets. You

can also feel the pen you're coloring with, sense its texture, you can smudge and smear with your own fingers. And there's no "undo" button.

**It's cheap.**

Adult coloring books don't cost much. They come in all kinds of sizes and prices, so they fit everyone's needs (and pockets). After all, it is way cheaper than therapy.

In summary, coloring for adults is a growing past-time that allows adults to relax and unplug from the stress in their lives by engaging in a hands-on activity that involves minimal commitment and maximum nostalgia.

# COLORING TOOLS

Congratulations on your adventure into adult coloring!

You may have some colored pencils, markers or even crayons already. Or you could swipe your preschooler's crayons - but you'll enjoy adult coloring books more if you splurge on some tools of your own.

Here is some basic information on various tools used for coloring to help you decide what to use. These include colored pencils, watercolor pencils, gel pens, and markers.

There are advantages and disadvantages to each and it's good to know these before making your choice. You could even get a few of each and try all of them!

**Colored Pencils**

Advantages: Colored pencils are available in a large variety of colors. They can be sharpened to a fine point which is great for detailed coloring images. They can be blended using blending tools and other techniques.

Disadvantages: Some people find that they cause their hands to hurt because of the added pressure required to use them. They need to be sharpened often and can quickly become short. A pencil extender can help with using short pencils. The lead inside them can break if they are dropped.

**Watercolor Pencils**

Advantages: Watercolor pencils are ideal for blending.

Disadvantages: Many books are printed on paper that is not suitable for using watercolor pencils. The paper can buckle when wet. Using too much water can cause your colors to run together.

## Gel Pens

Advantages: Fine details are easier to color with gel pens. They are available in metallic and glitter colors not available with pencils.

Disadvantages: Gel pens will run out of ink fairly quickly when coloring a lot and will need to be replaced. Gel pens are also more likely to skip on the paper.

## Markers

Advantages: Markers are the easier to apply color as not as much pressure is needed. They are ideal if you have hand issues such as arthritis or cramping. They are quicker for coloring than colored pencils.

Disadvantages: Bleed through is a big issue when coloring with markers. Any image on the backside of a page will be ruined from bleed through. On single sided coloring books, like those from My Time To Color, you won't loose half your images on the backside of the pages. However, you should still put paper or cardboard behind the image to protect the next page.

## Crayons

Advantages: Using Crayons will really bring back those childhood memories. They are inexpensive though. They come in many colors and have an appearance to the color that is unlike any other coloring tool.

Disadvantages: Detail work is not very possible with Crayons. They can break in your hand while coloring much less if they're dropped. They will not have a sharp tip to them, making it difficult to fill in near the lines in a drawing.

Feel free to visit our website for more info on tools:

MyTimeToColor.com

# MARYLAND COLORING BOOK

The coloring images in this book are meant to be fun, creative representations of Maryland. They are not meant to be historically accurate or pictorially accurate depictions. We hope you enjoy these artistic creations for your coloring pleasure.

# TIPS FOR ADULT COLORING BOOKS

1. Always test any markers or gel pens you use on a page in the book. My Time To Color's books have additional pages in the back for you to use. See if it bleeds through or leaves a shadow.
2. Slip a piece of paper, or a few, behind the page you are coloring. This protects the pages behind from bleeding or denting from heavy coloring.
3. Sharpen your coloring pencils often.
4. Slow down and relax – enjoy the coloring.
5. Go to an art store in town to check how different pencils feel and draw. This will help you decide which ones you like.
6. Buy the largest selection of colors that you can afford. It ends up being cheaper then buying a small box of 12 or 24 and having to add in single pencils of additional colors.
7. Look for local coloring groups. Check Meetup and your local library.
8. Have fun and color inside or outside the lines... it's ok!

Annapolis is known as the sailing capital of the world.

_____

_____

_____

_____

_____

The Baltimore Oriole is Maryland's State Bird.

The Baltimore Orioles are the state's Major League Baseball team.

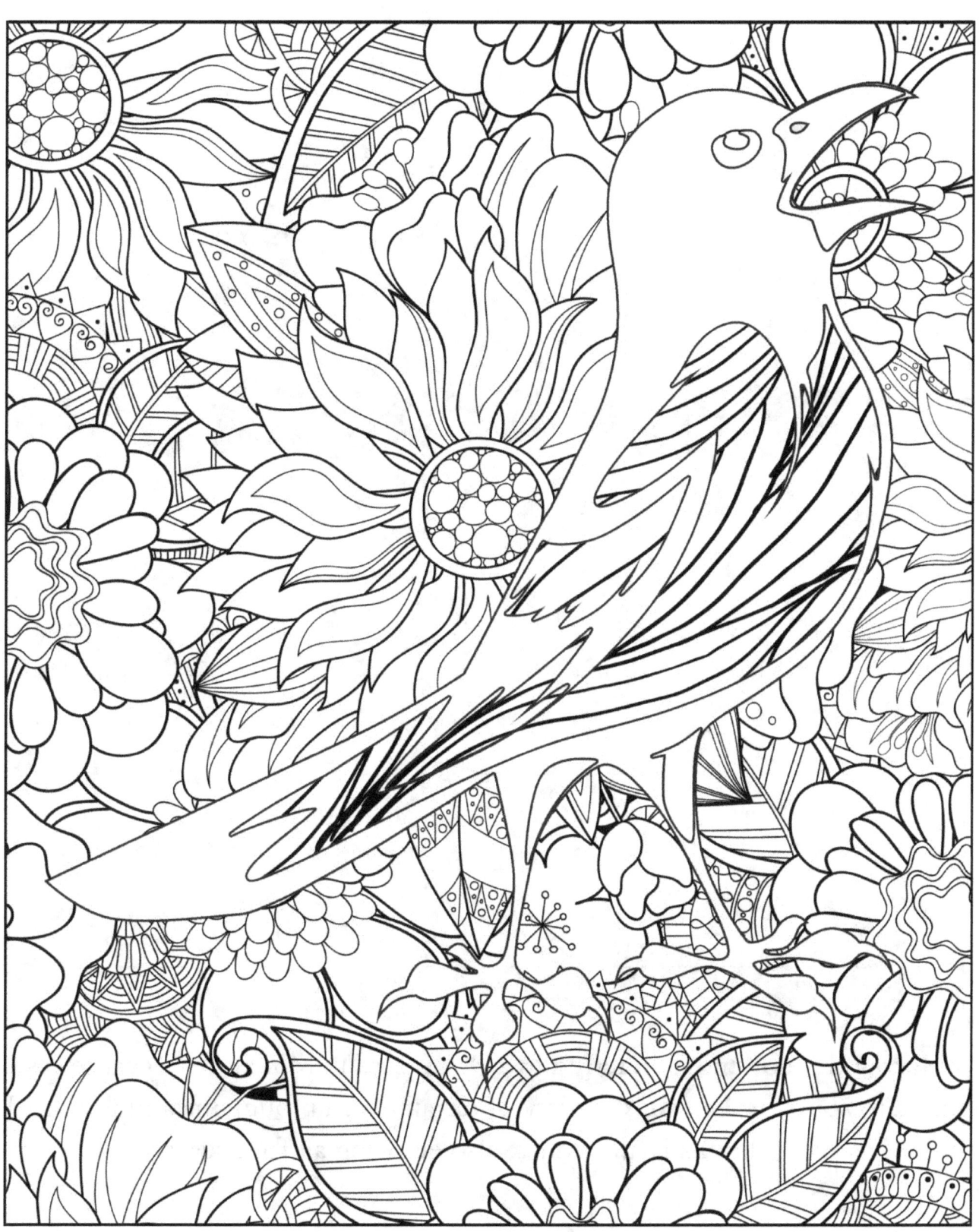

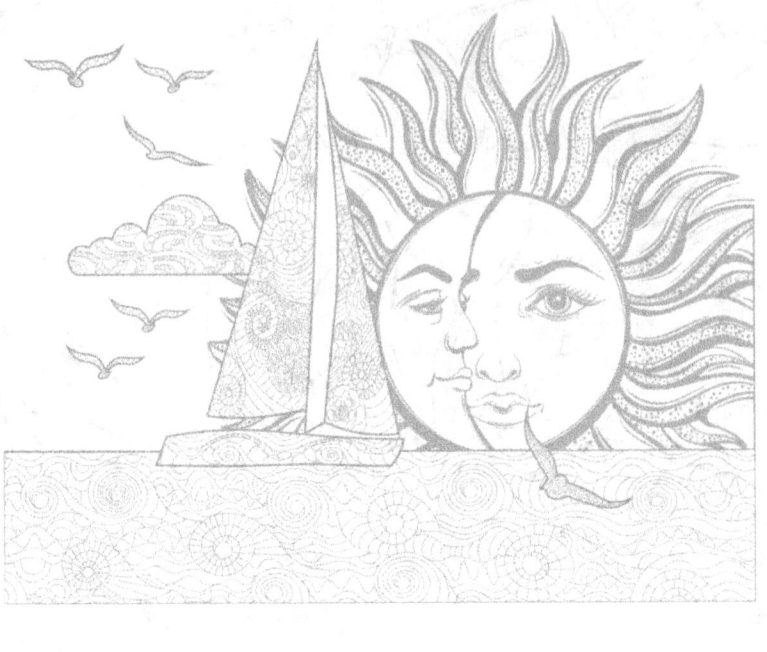

_____

_____

_____

_____

Maryland is commonly referred to as "America in Miniature" because it's home to some of the widest variety of terrain from mountains and farmland to beaches and sand dunes, also enjoying all four seasons.

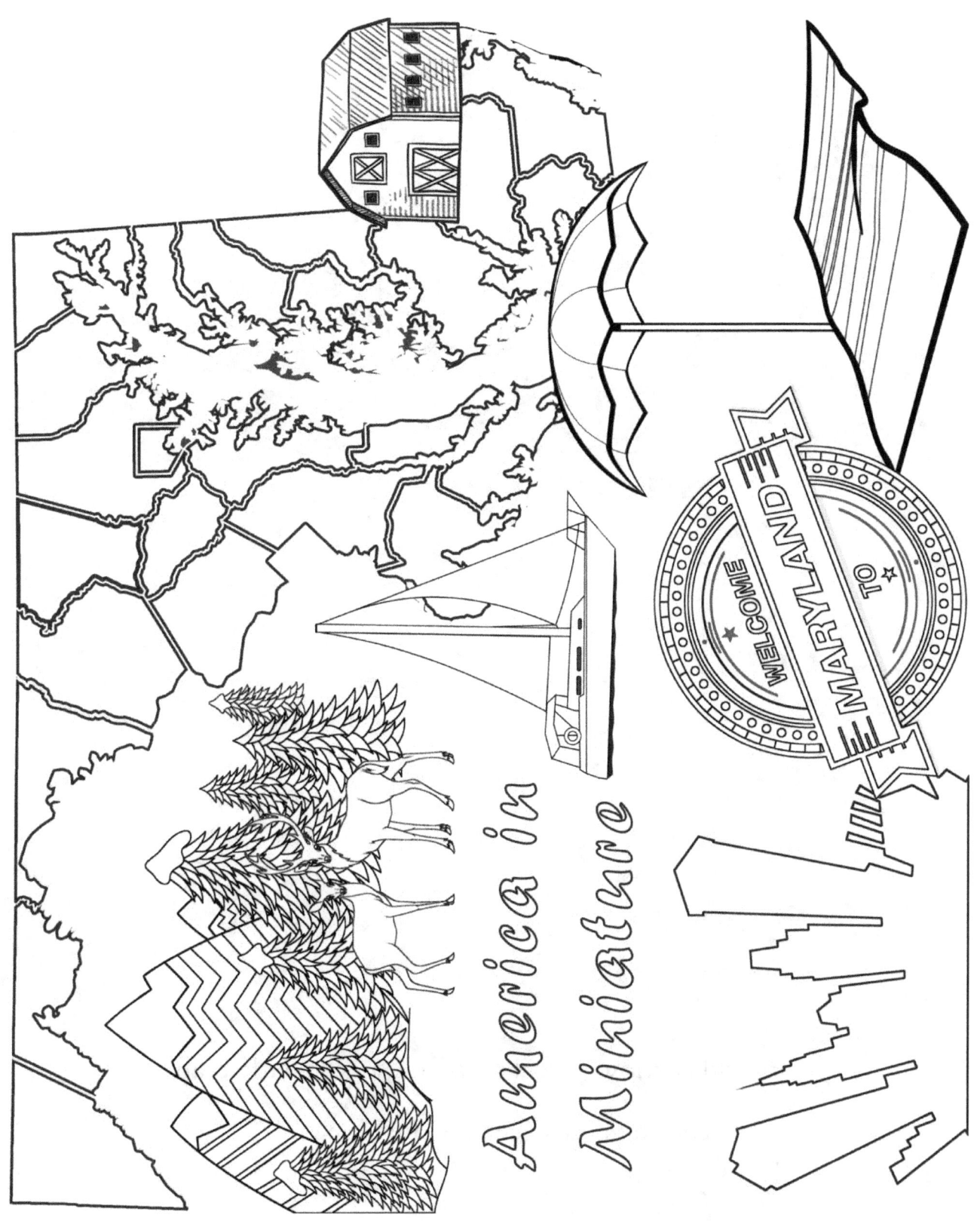

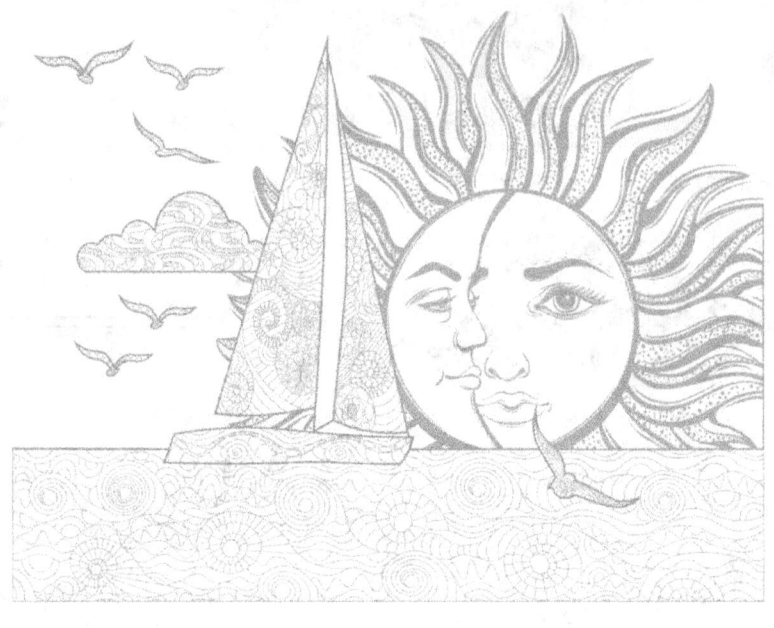

_____

_____

_____

_____

_____

Maryland is known for its seafood, particularly crabs.

The state crustacean is the blue crab.

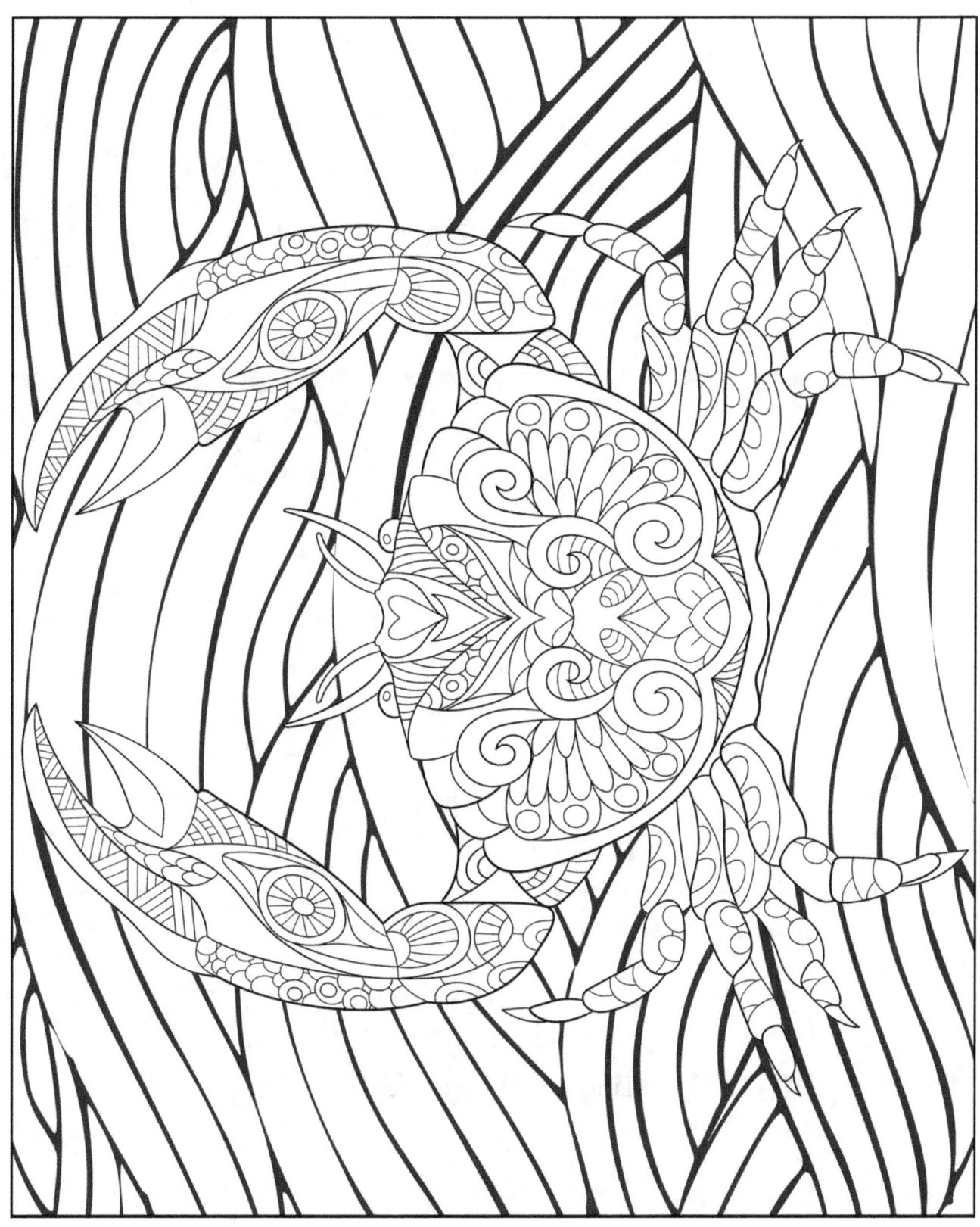

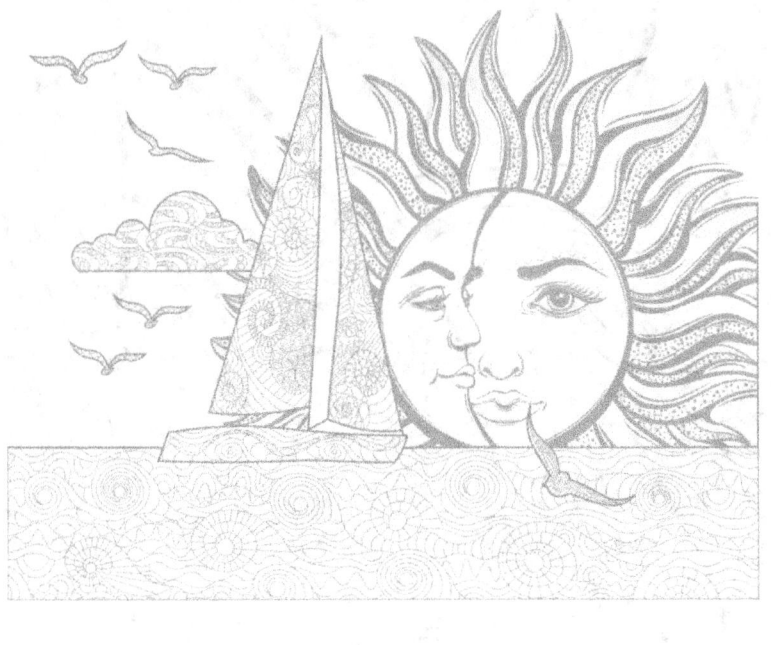

The Maryland state tree is the White Oak.

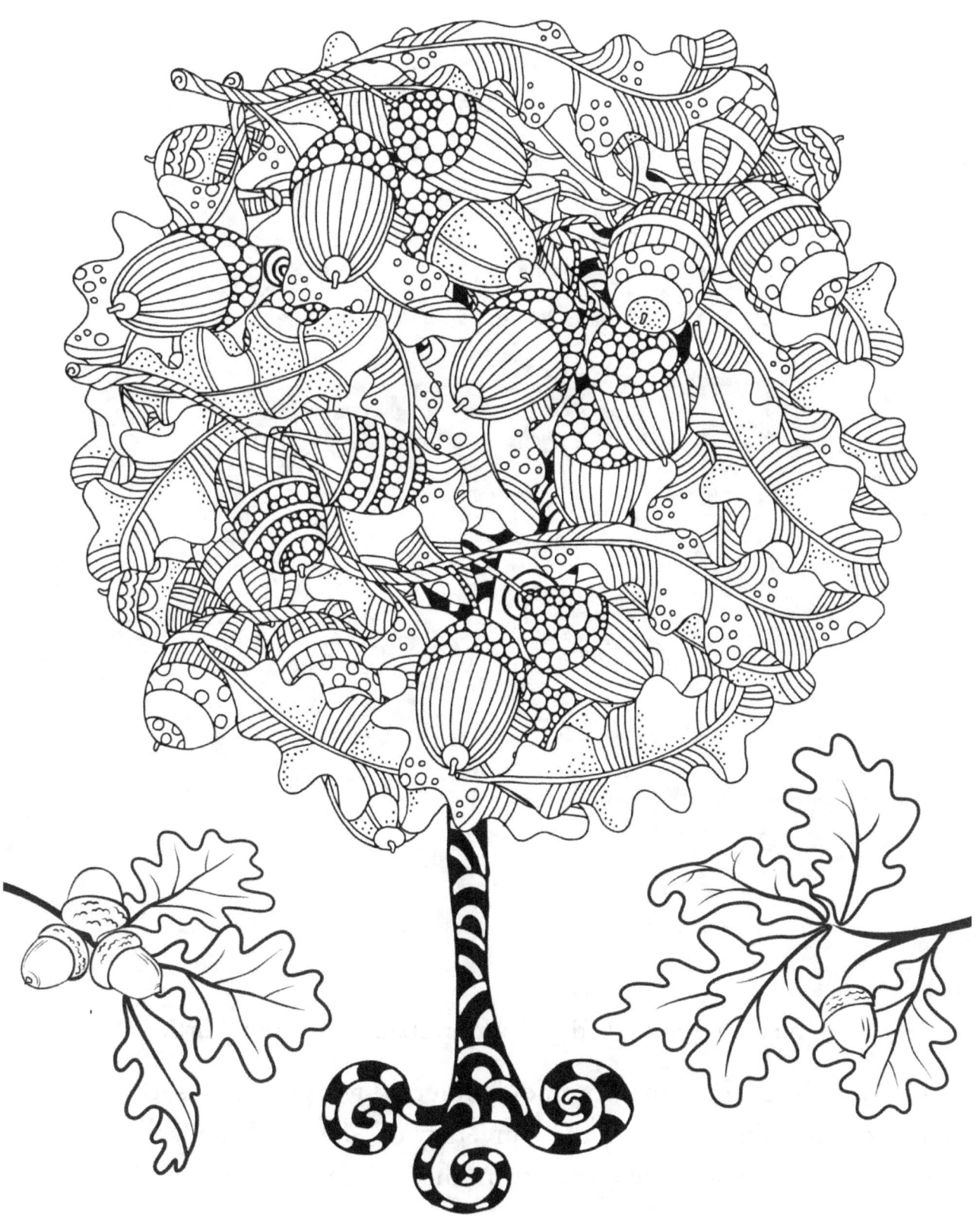

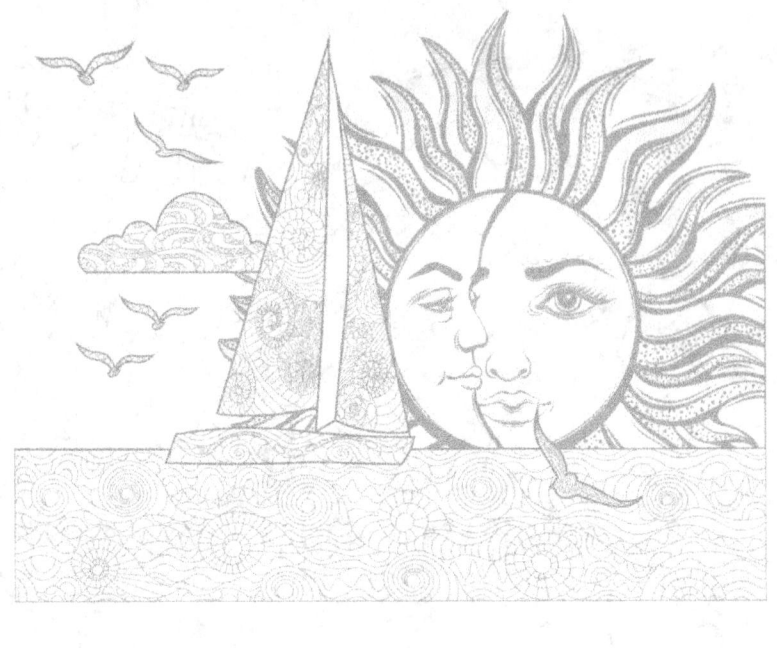

_____

_____

_____

_____

_____

The state reptile is the Diamondback Terrapin Turtle.

The Maryland Terrapins, commonly referred to as the Terps, consist of athletic teams that represent the University of Maryland, College Park and their name comes from the Terrapin Turtle.

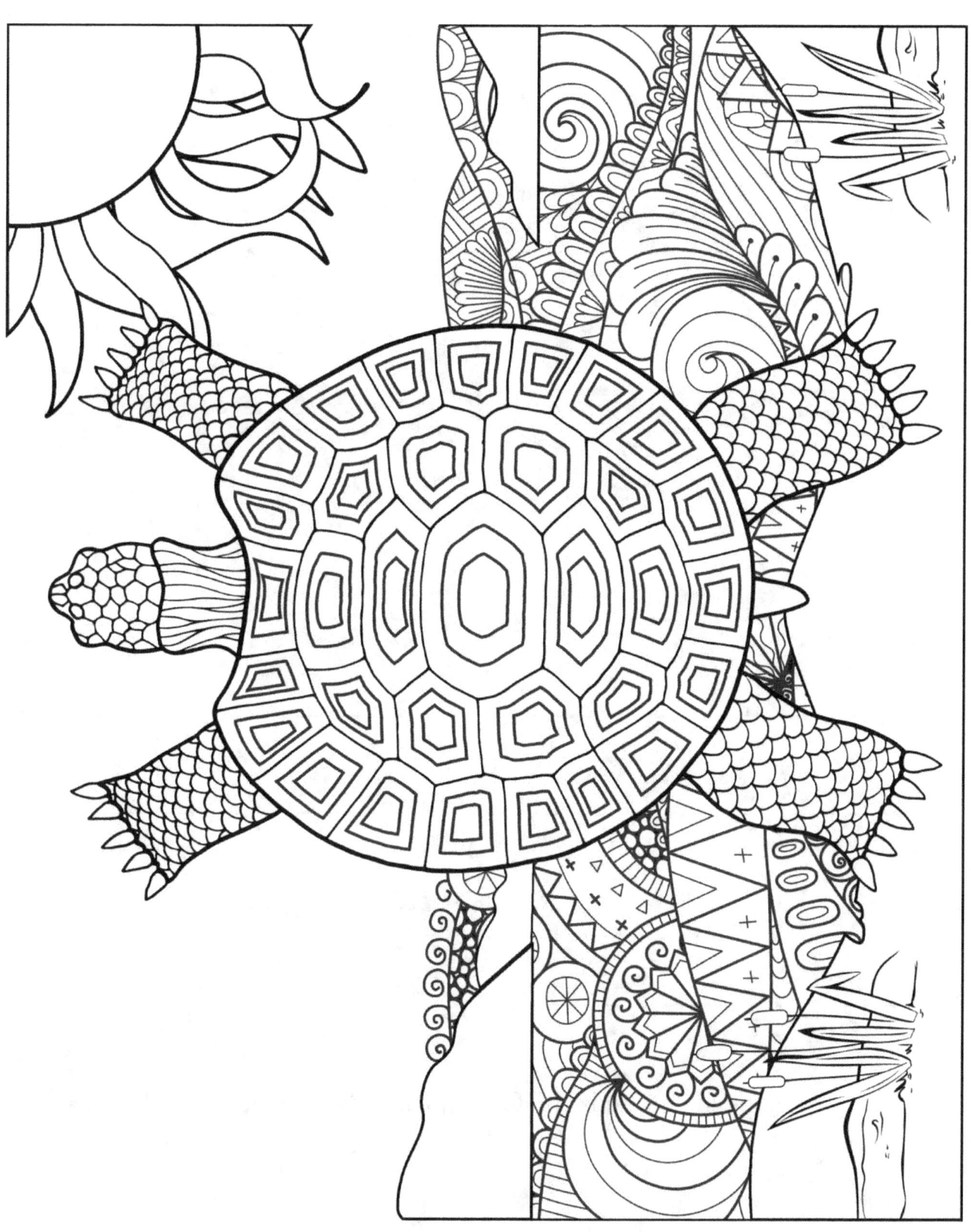

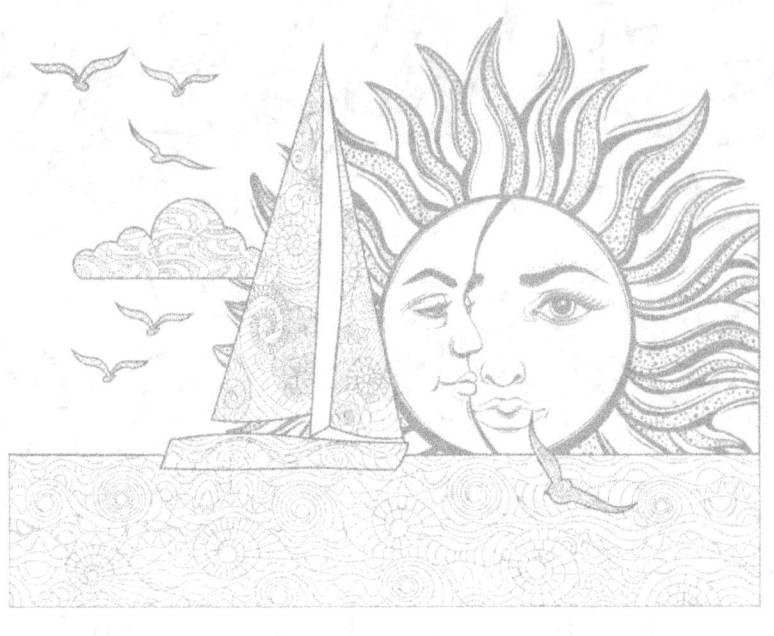

_____

_____

_____

_____

The state dog is the Chesapeake Bay Retriever.

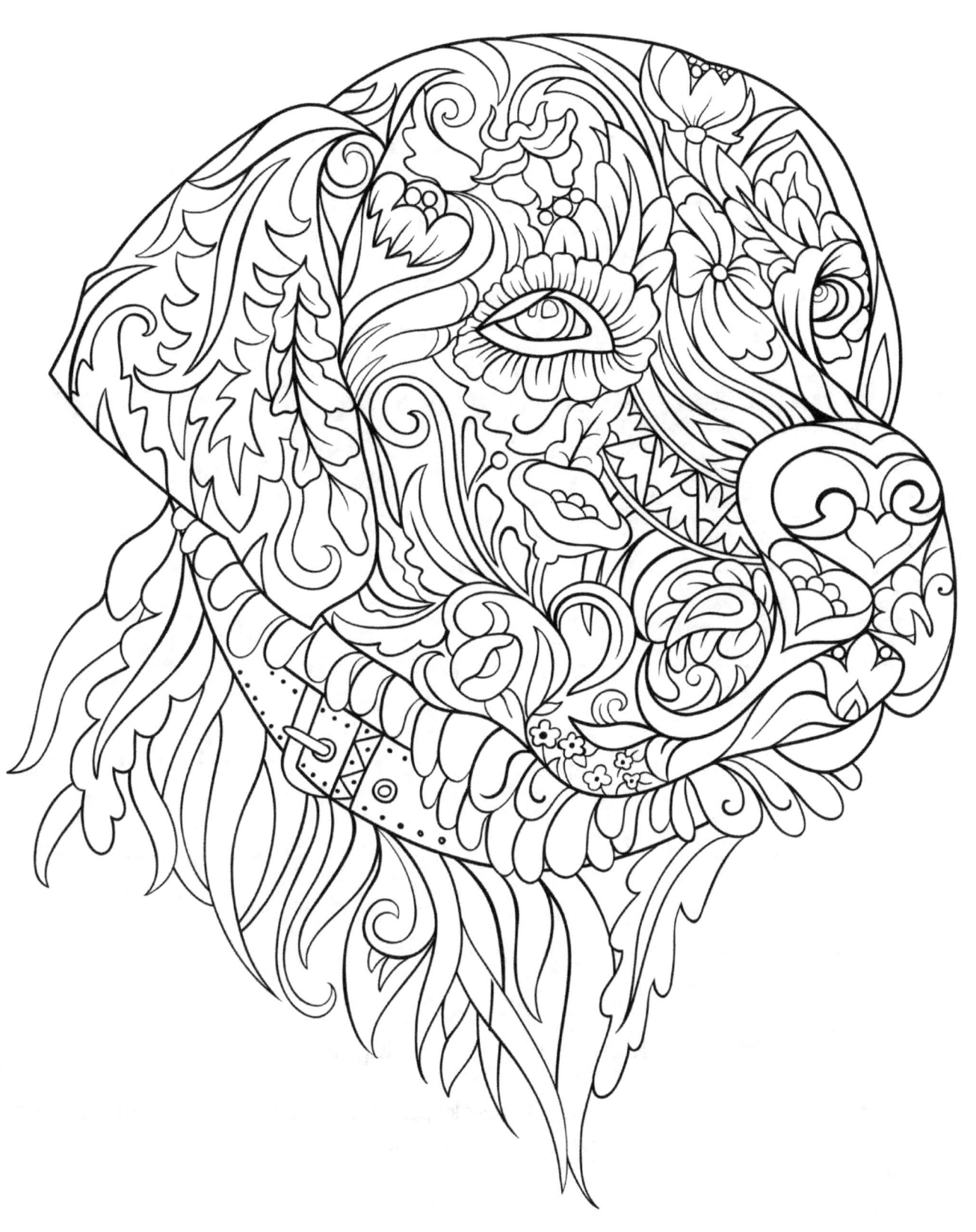

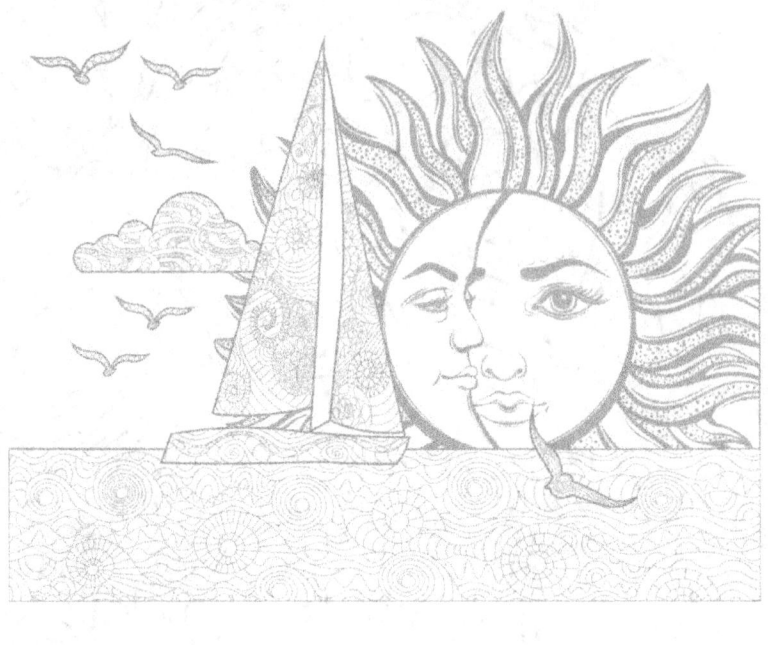

_____

_____

_____

_____

The state boat is the Skipjack.

Tilghman Island is home to the Skipjacks, the only commercial sailing fleet in North America.

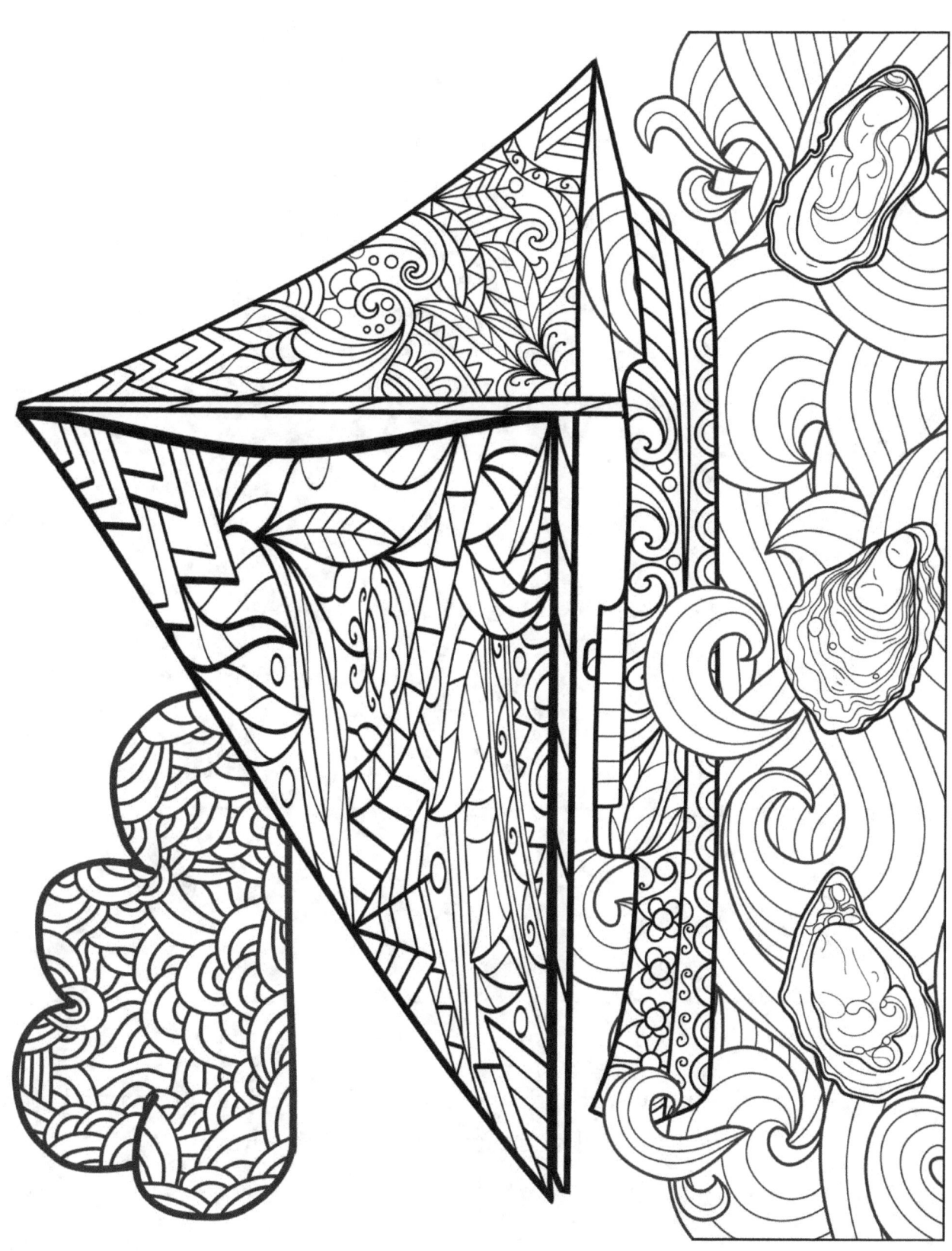

_____

_____

_____

_____

_____

Baltimore's National Football League team, The Ravens, are named after Edgar Allan Poe's famous poem, The Raven.

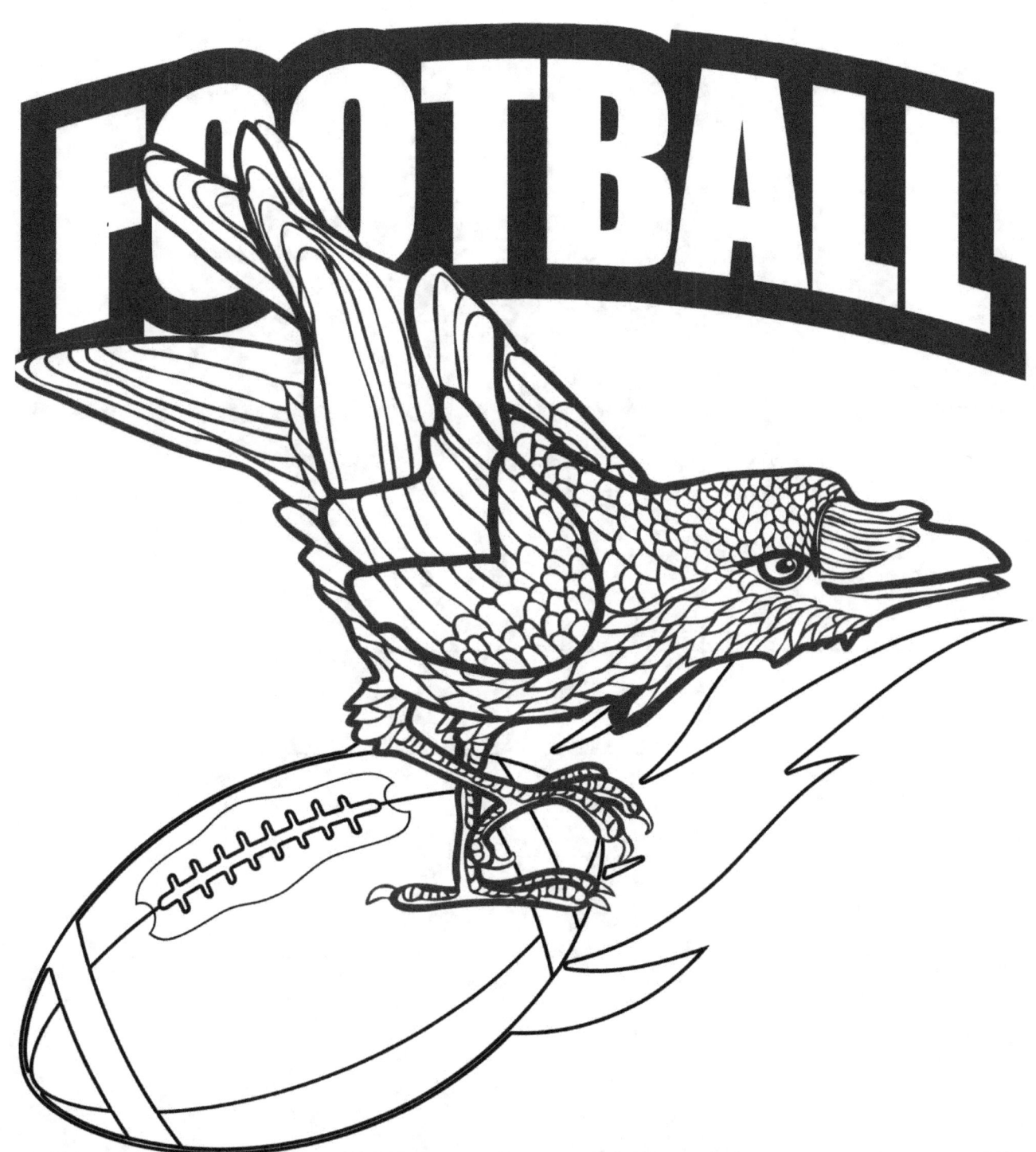

Quoth the Raven "Nevermore."
Edgar Allan Poe

_____

_____

_____

_____

Maryland's state drink is milk.

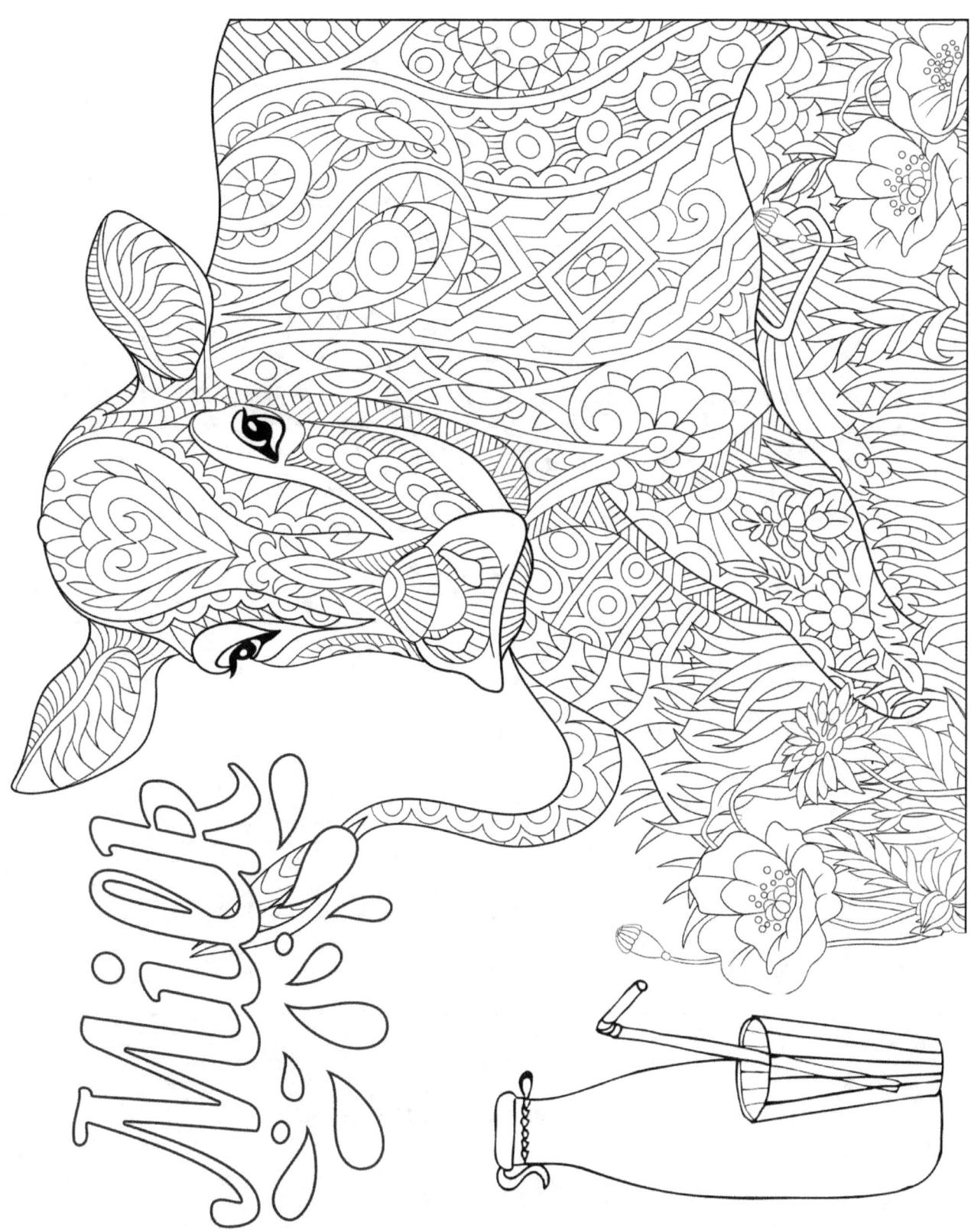

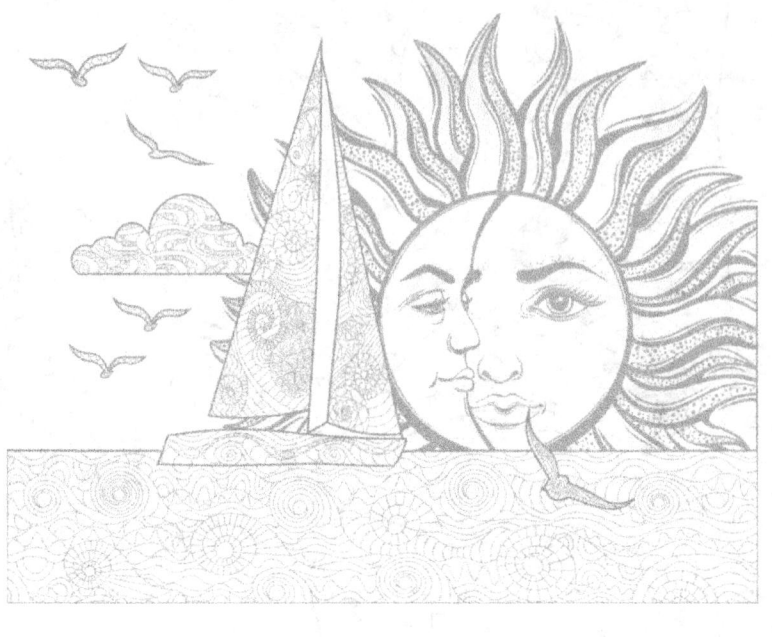

_____

_____

_____

_____

_____

The state team sport is lacrosse.

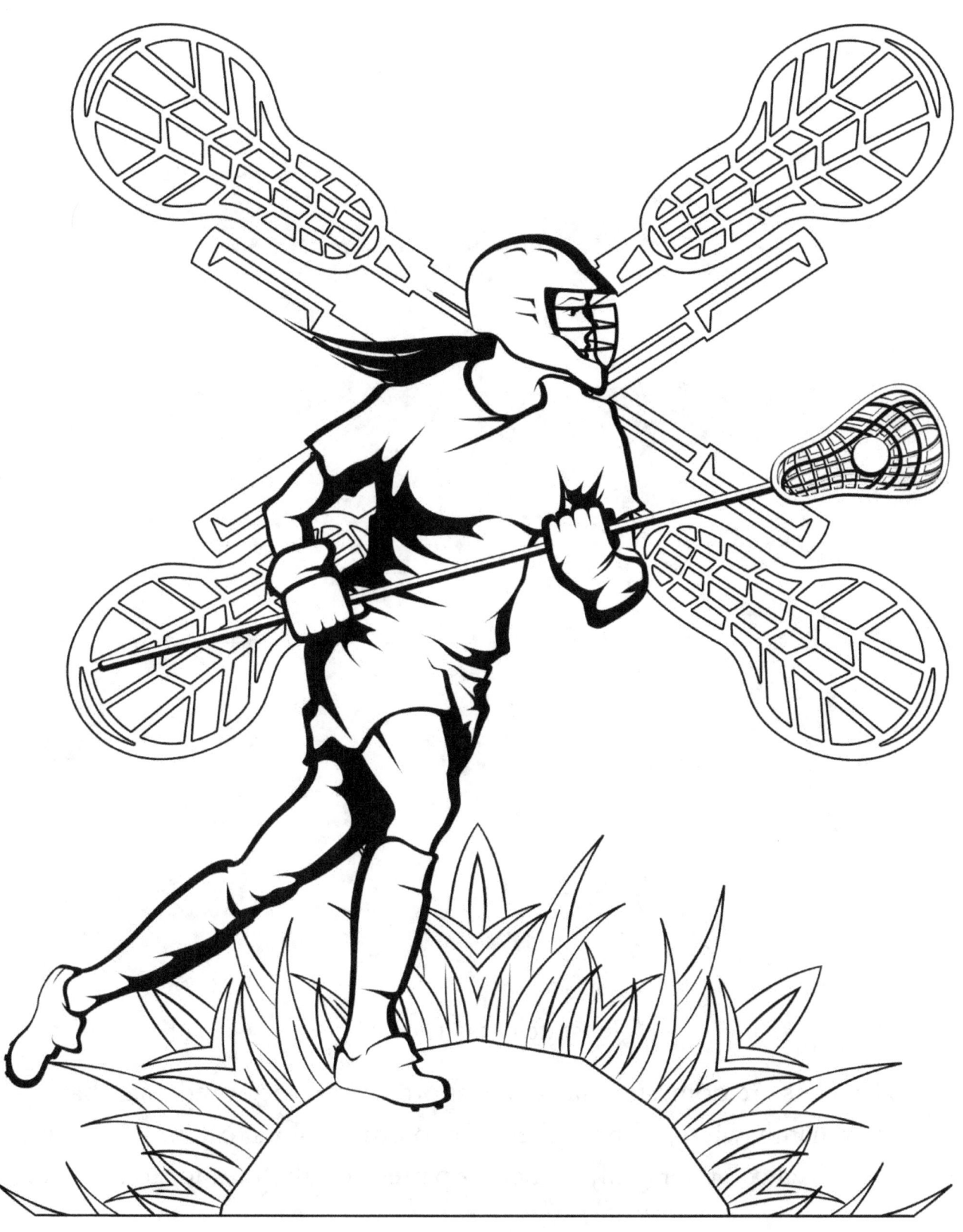

_____

_____

_____

_____

_____

The state cat is the Calico.

Calico cats are domestic cats with a spotted or particolored coat that is predominantly white, with patches of two other colors (often, orange and black). "Calico" refers only to a color pattern on the fur, not to a breed.

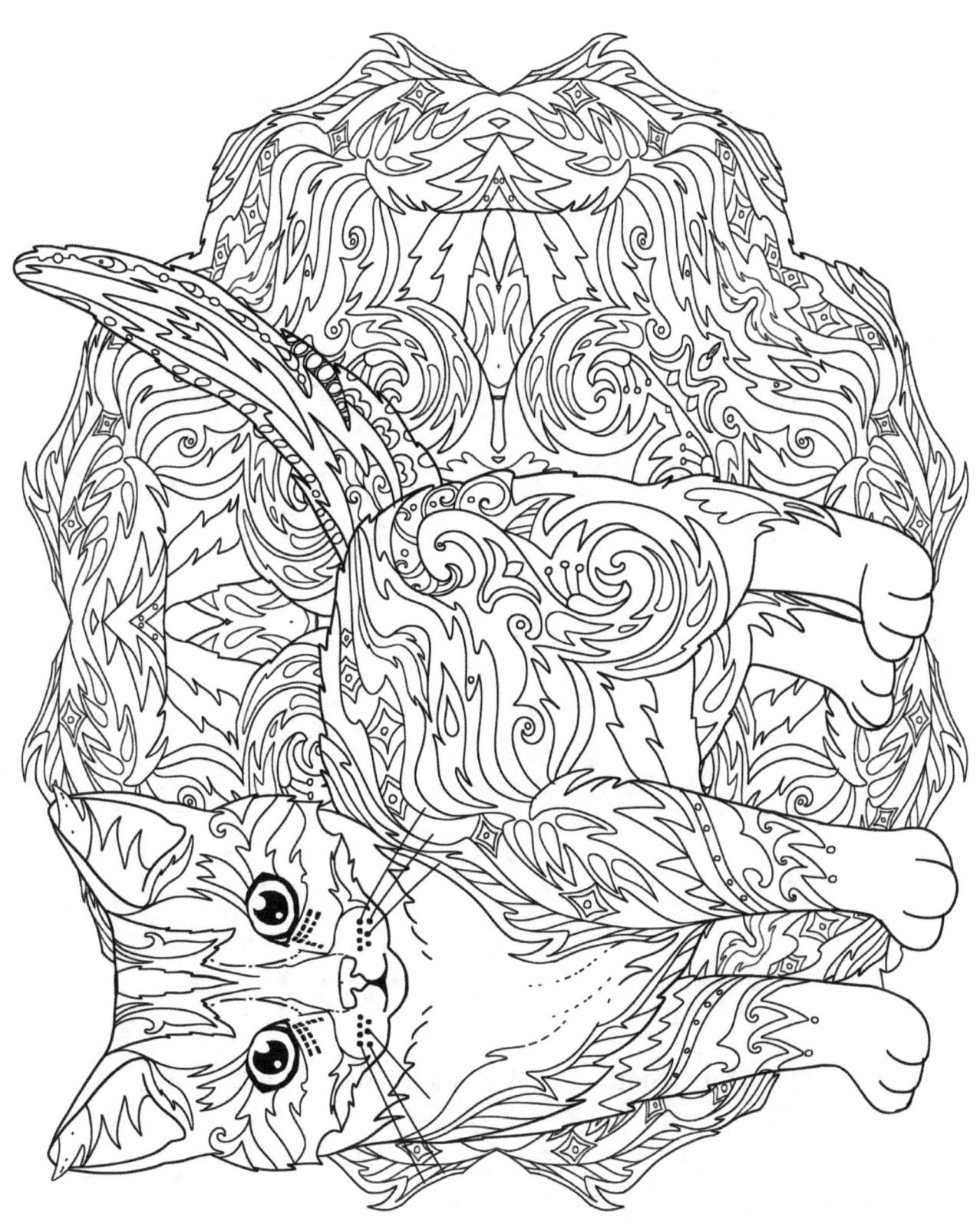

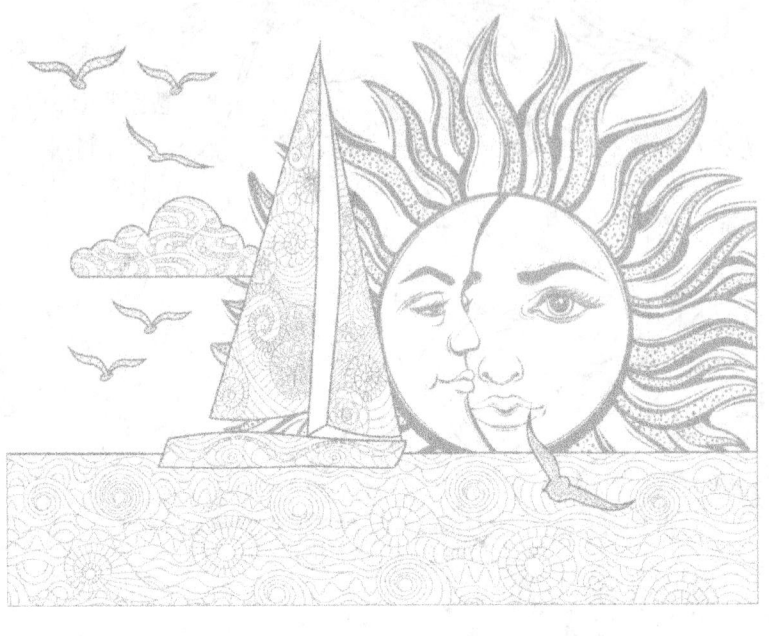

The United States Naval Academy was founded on October 10, 1845 at Annapolis.

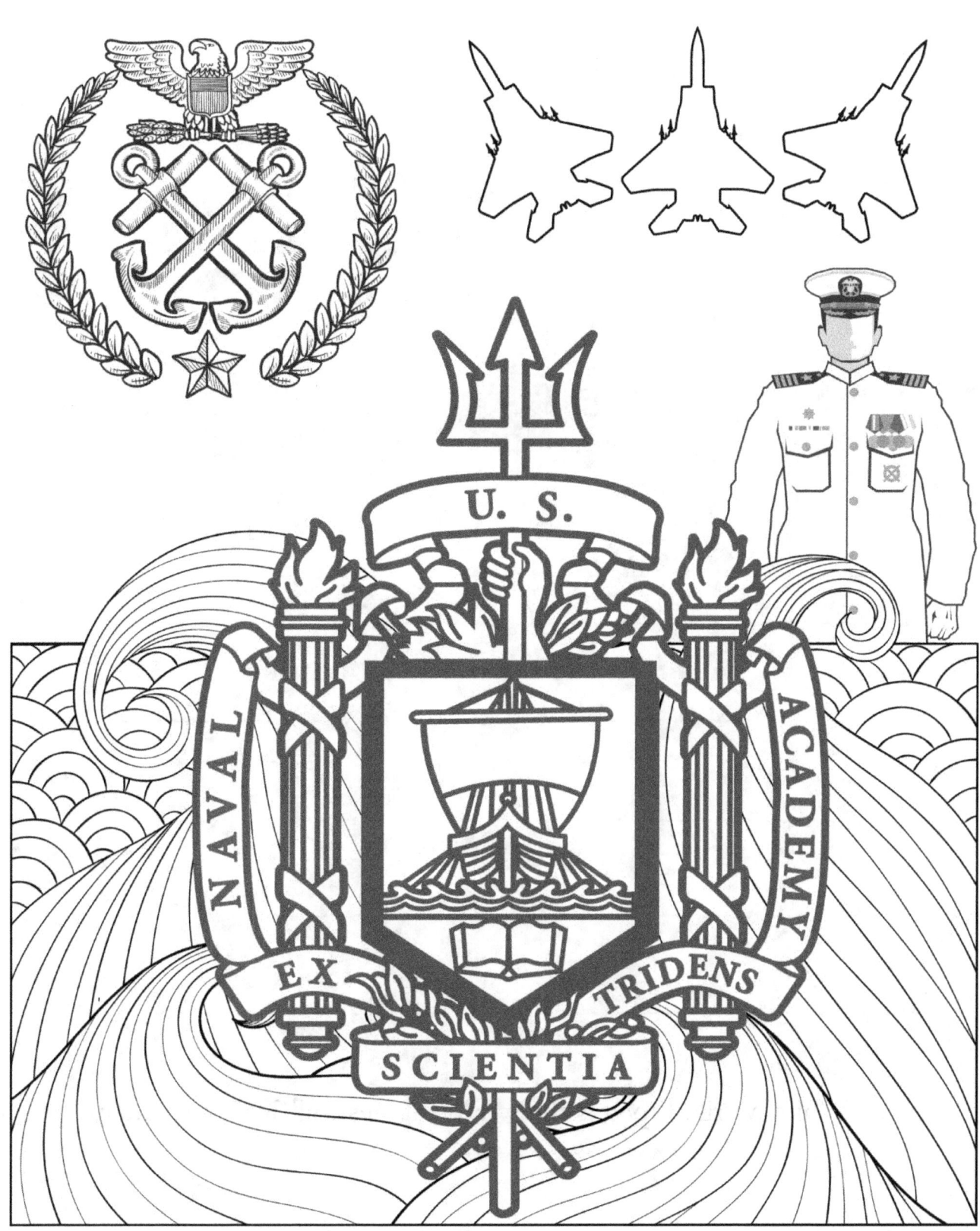

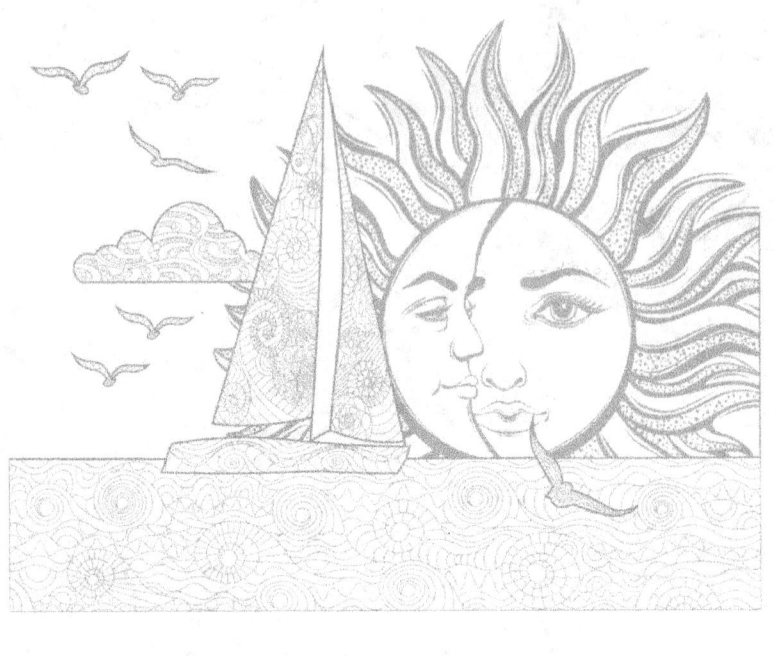

The White Marlin Open is the world's largest billfish tournament.

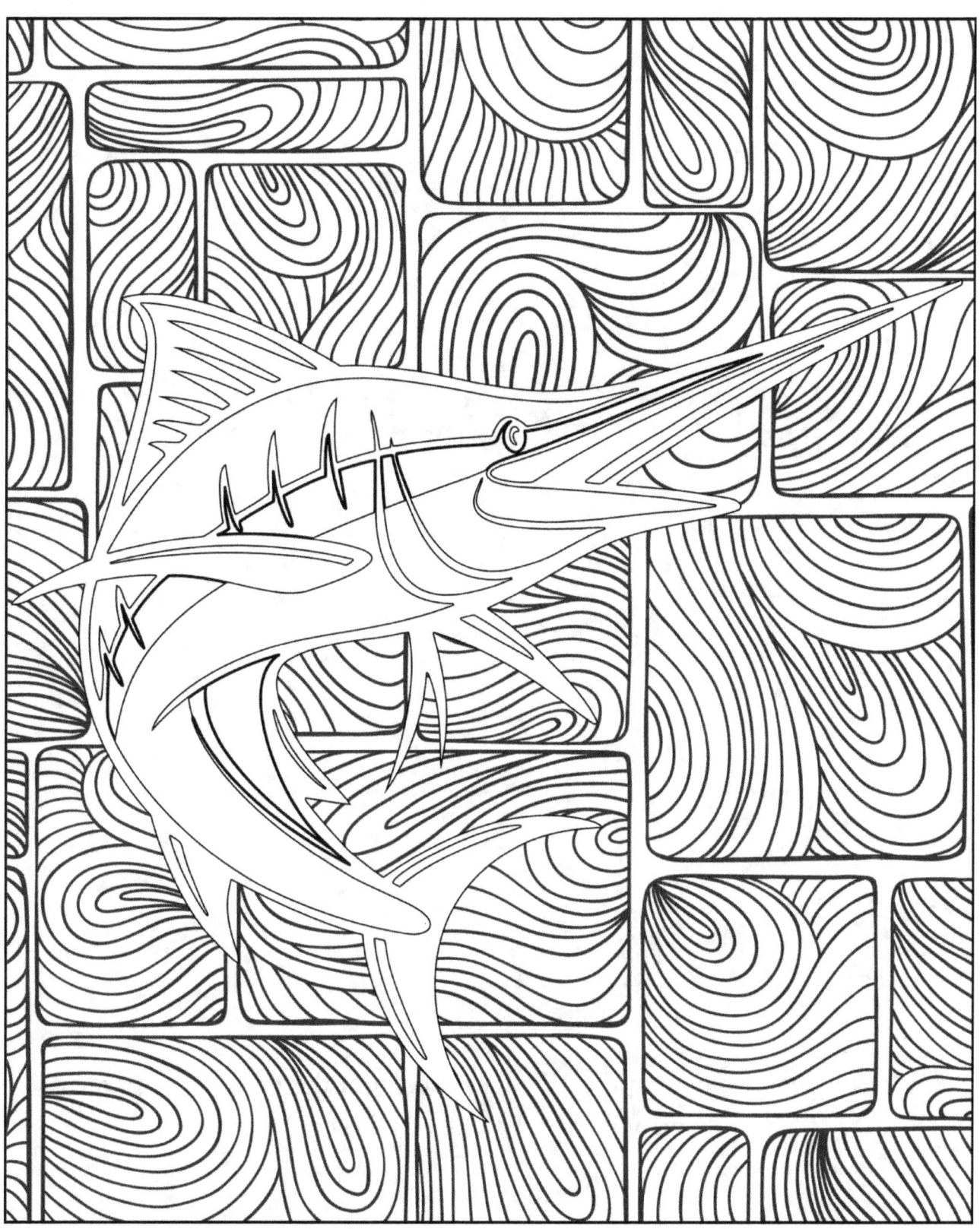

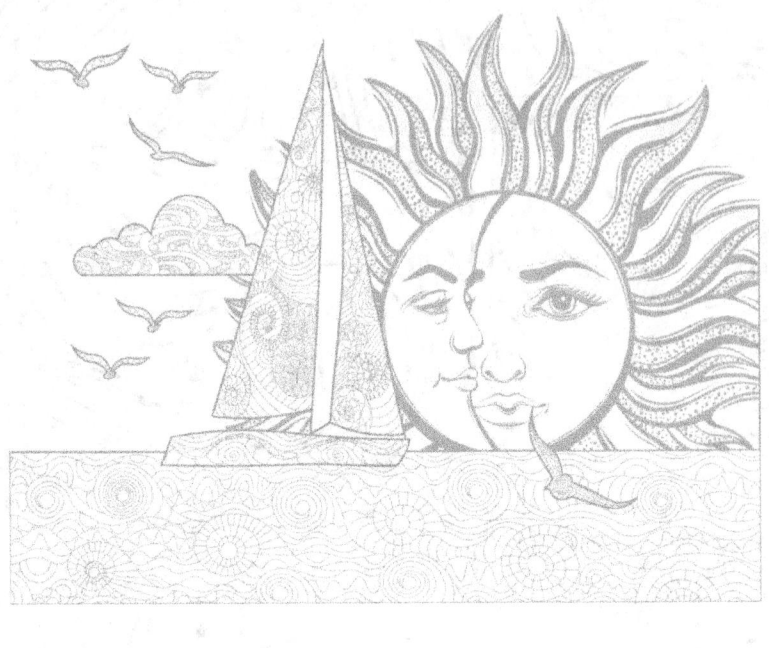

_____

_____

_____

_____

_____

Ocean City was named the 10th-best beach in the country as part of TripAdvisor's 2017 Travelers' Choice Awards.

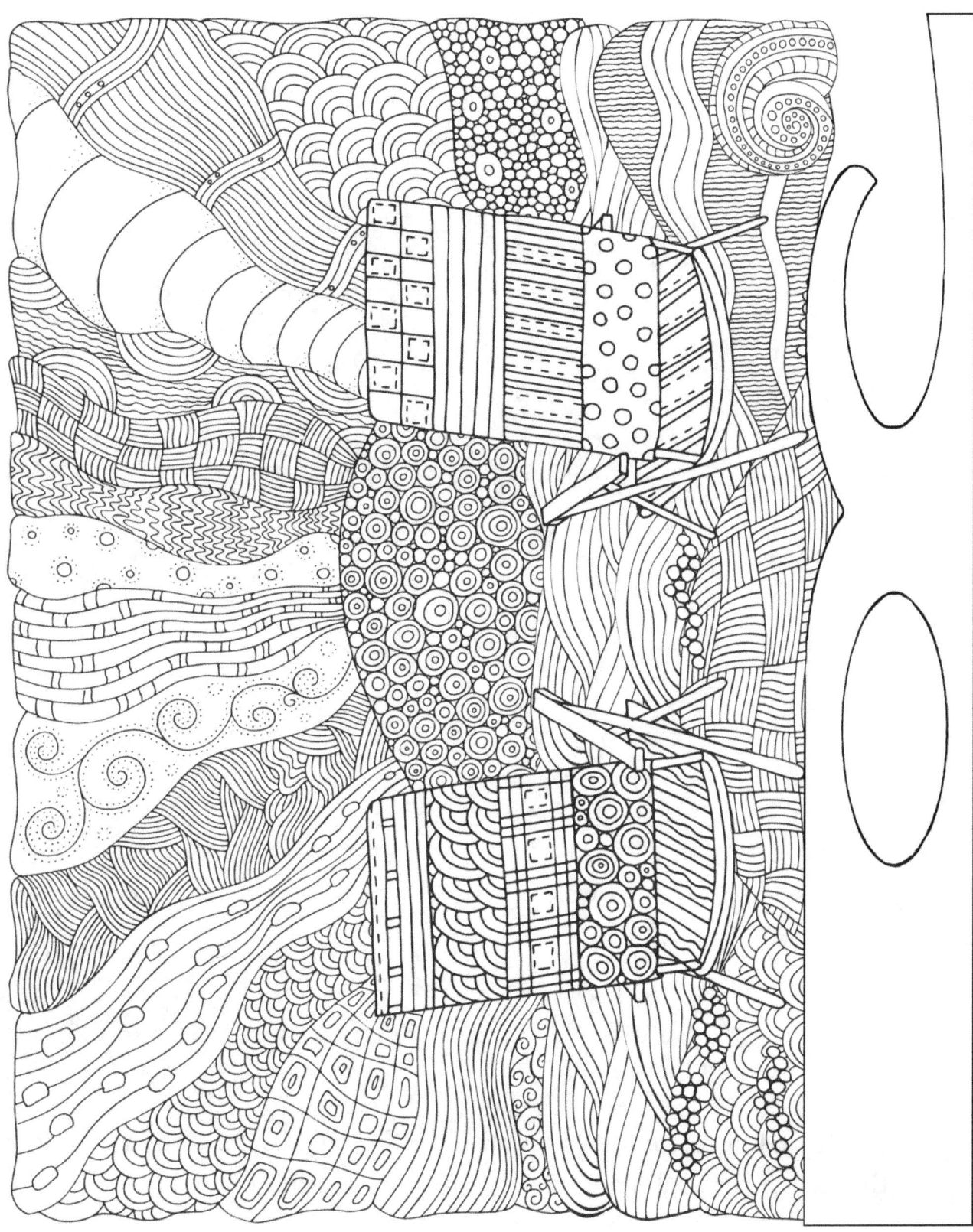

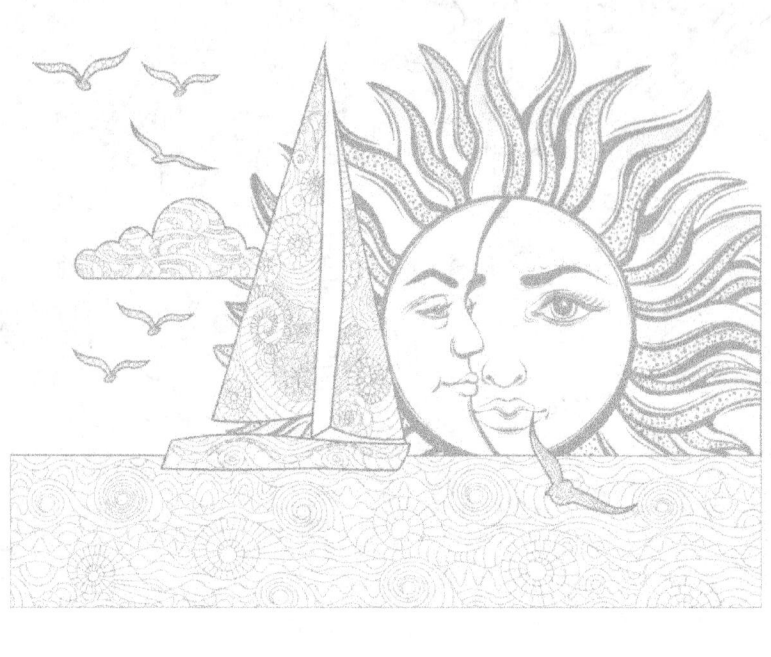

_____

_____

_____

_____

_____

On June 24, 1784, in Baltimore, 13-year old Edward Warren went airborne in the first successful manned balloon launch in the United States.

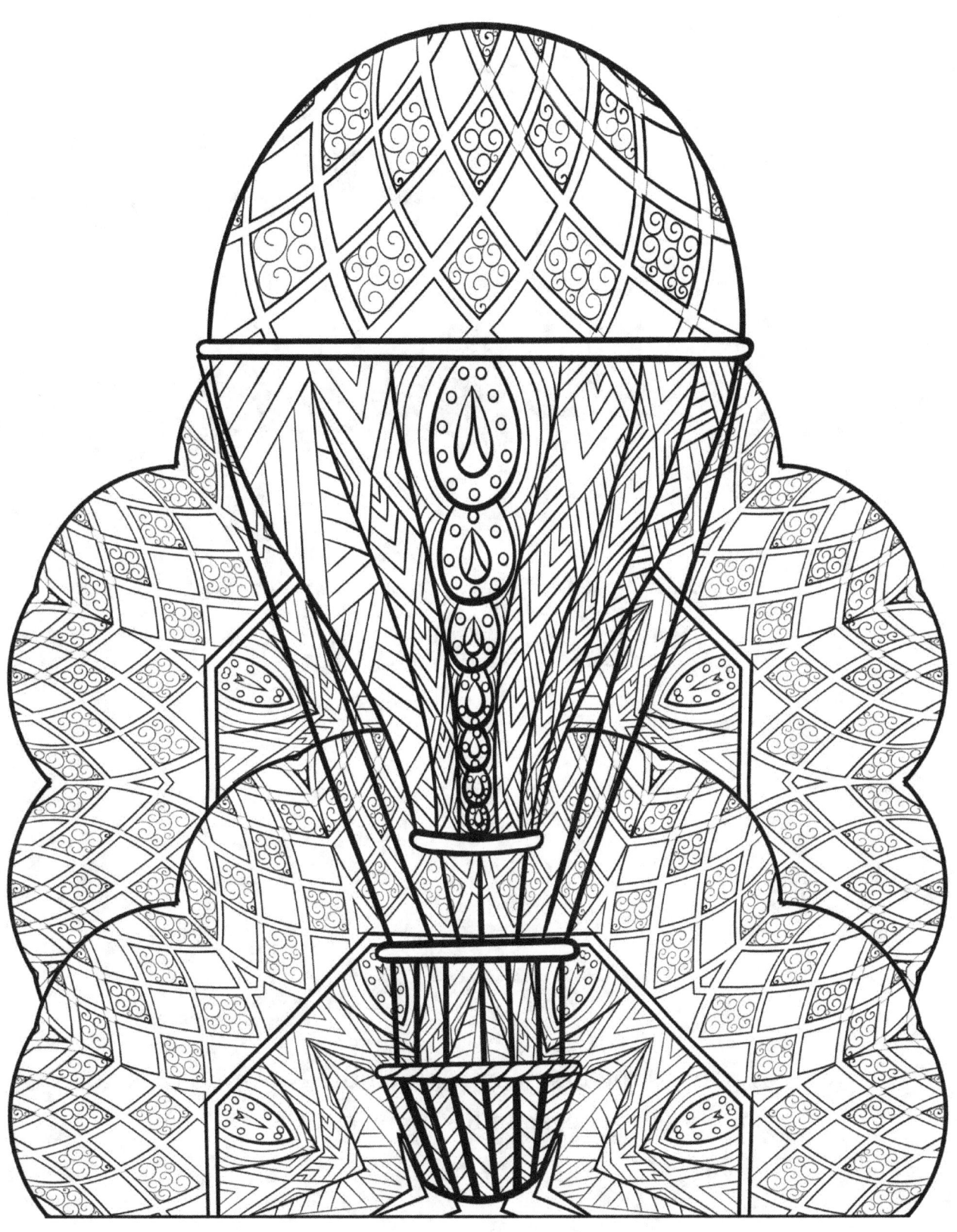

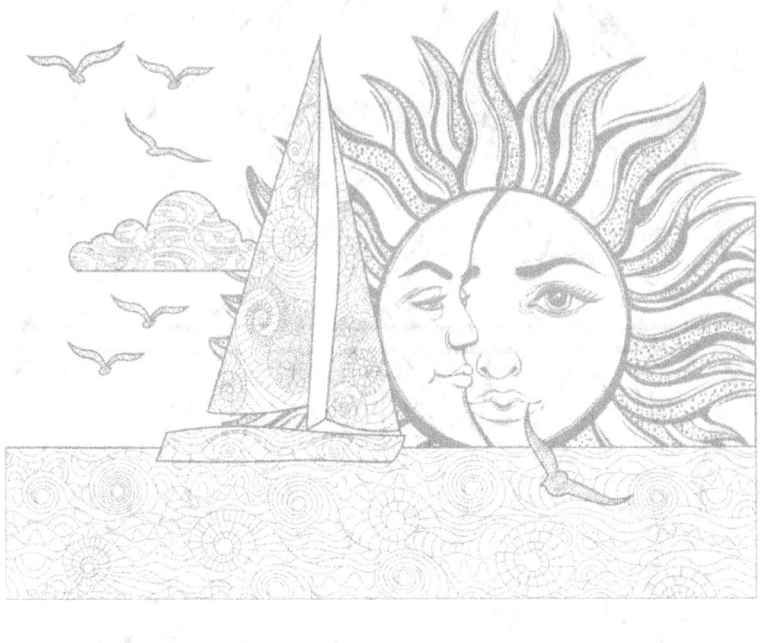

_____

_____

_____

_____

Widely recognized as the first man to reach the North Pole, Matthew Henson's journey began in his home state of Maryland.

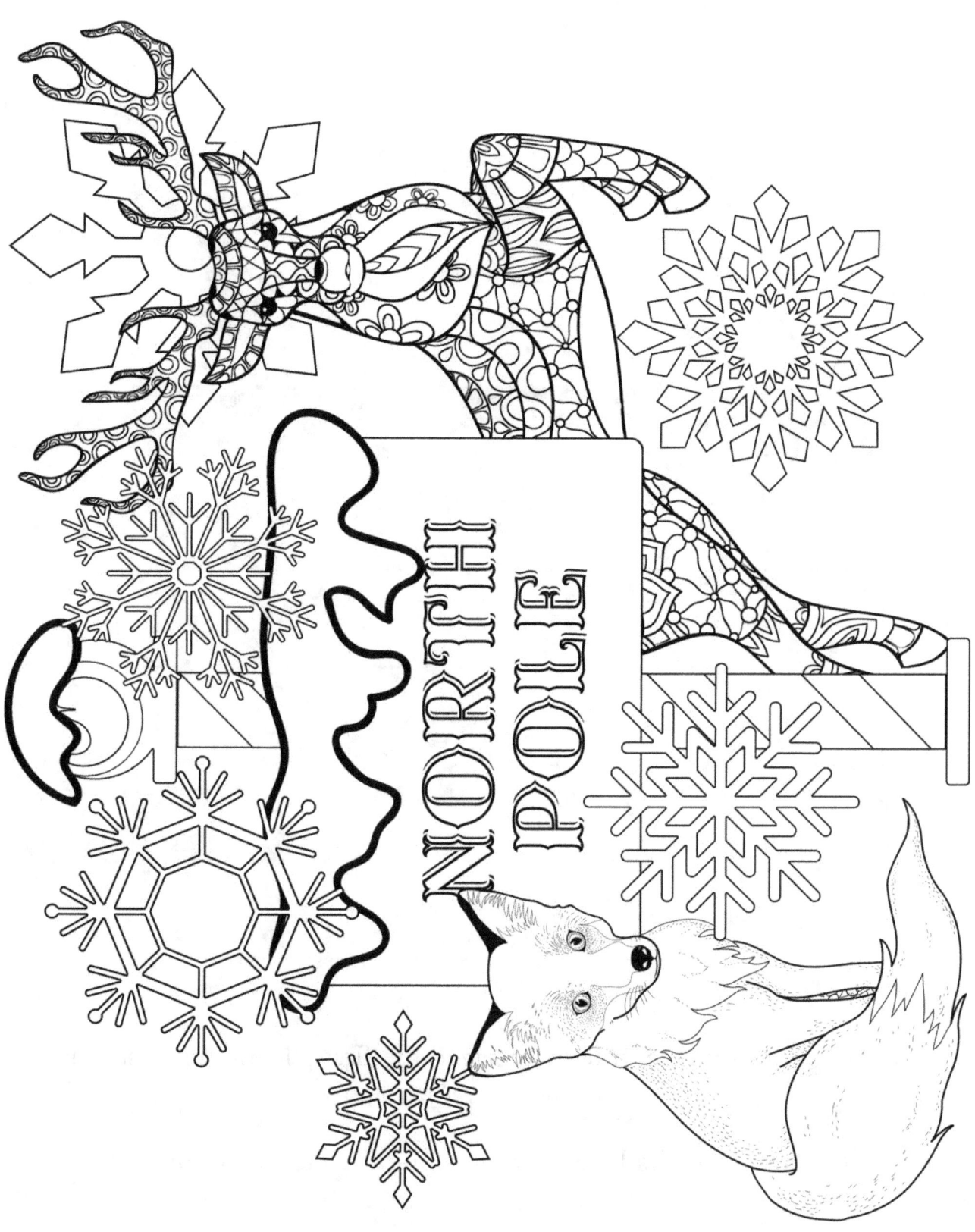

_____

_____

_____

_____

_____

Samuel F.B. Morse reportedly received the first telegraph message in Bladensburg, in 1844.

His telegraph wire had been strung along the railroad right of way.

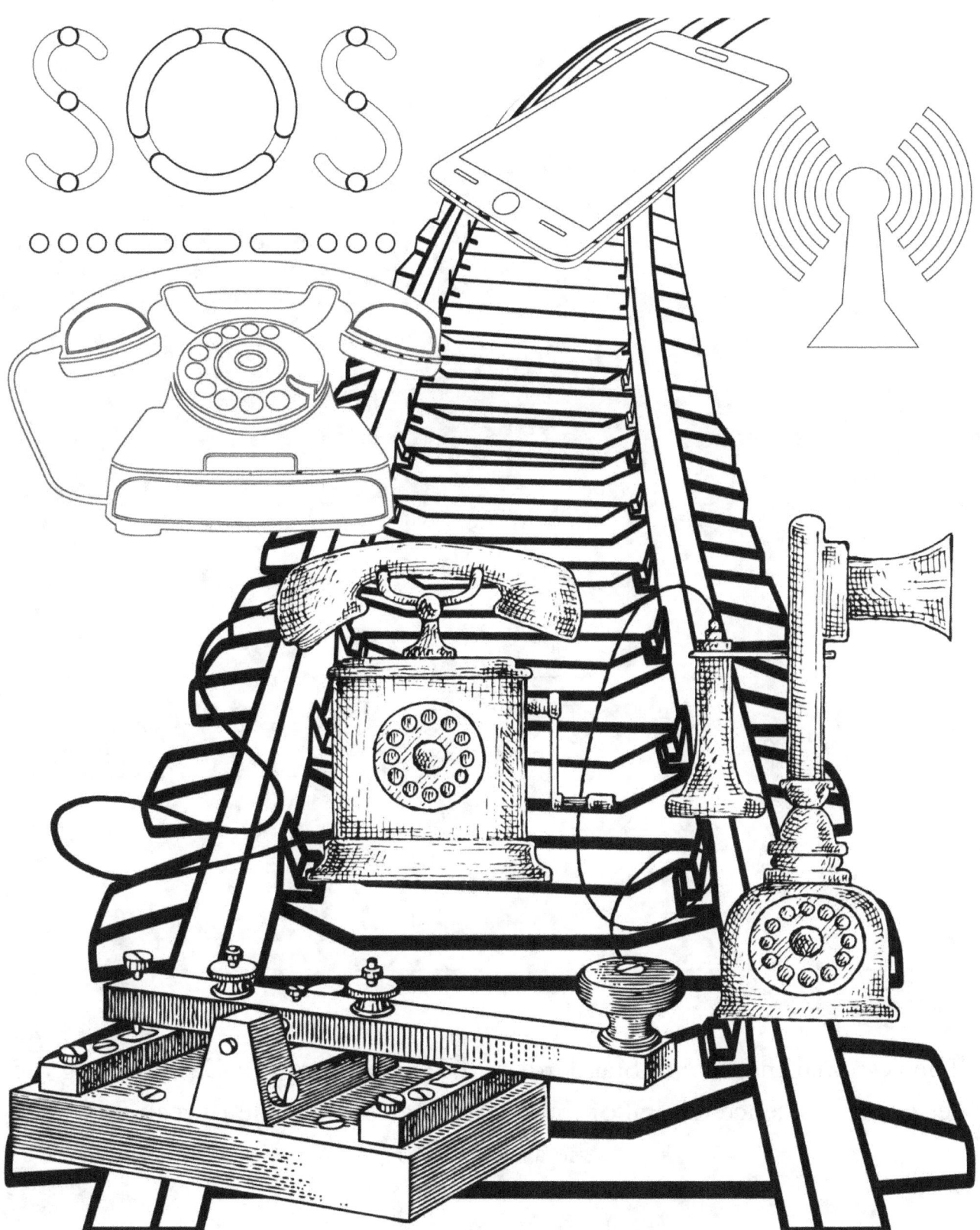

_____

_____

_____

_____

_____

The National Institute of Standards and Technology gave Gaithersburg the designation Science Capital of the United States when the Bureau moved to the area in 1961.

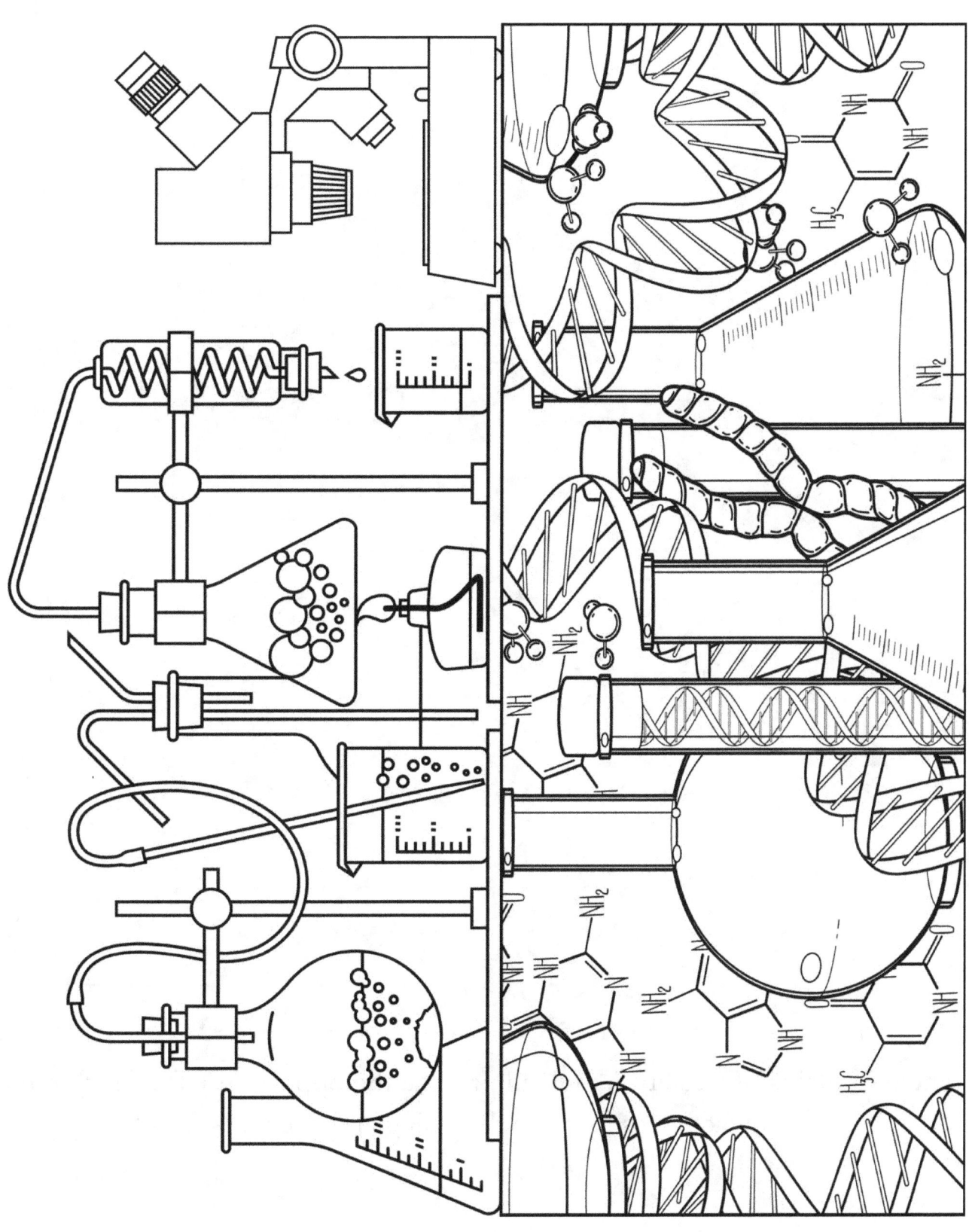

_____

_____

_____

_____

_____

The mountains of western Maryland provide the opportunity for fun winter activities like snowboarding and skiing.

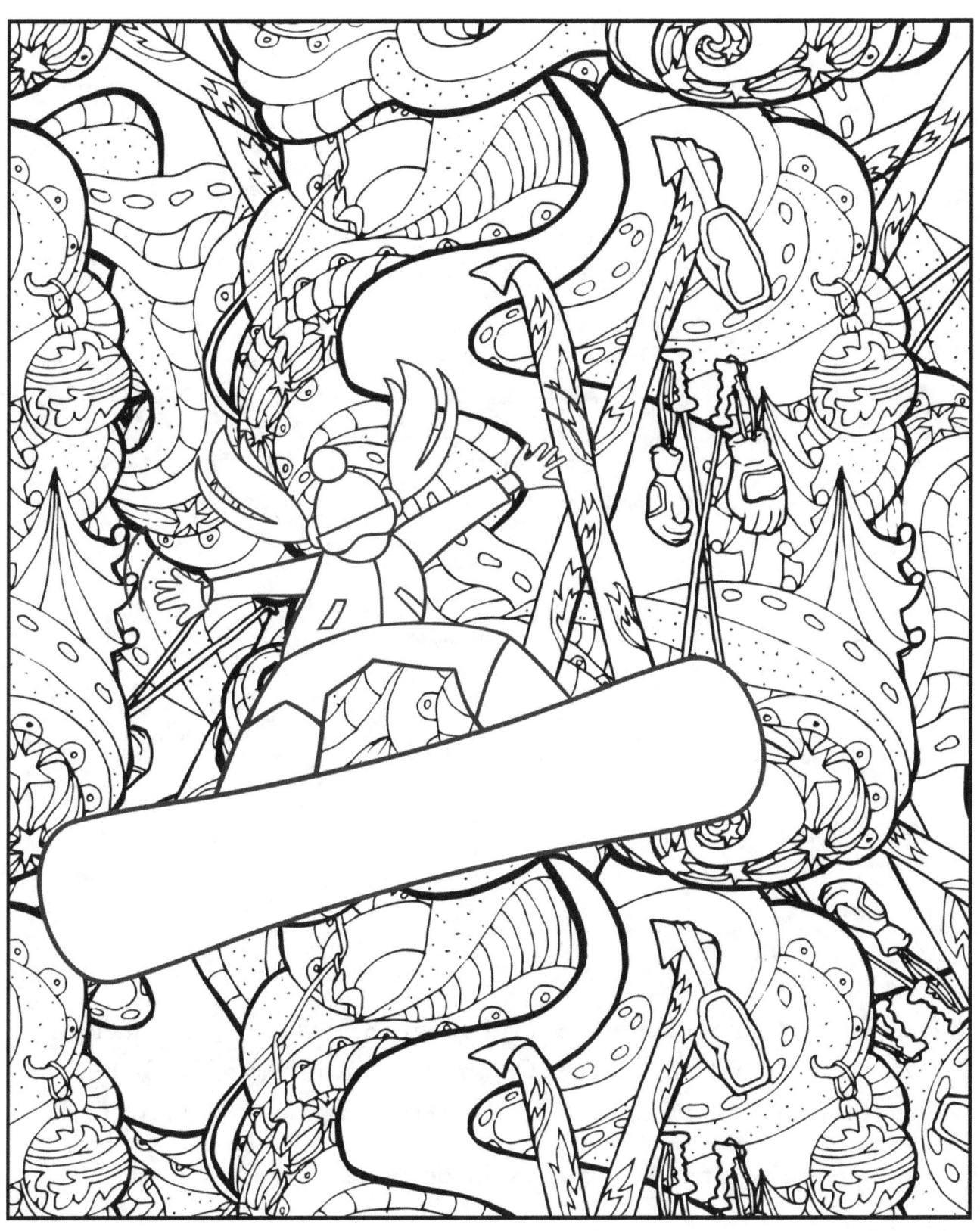

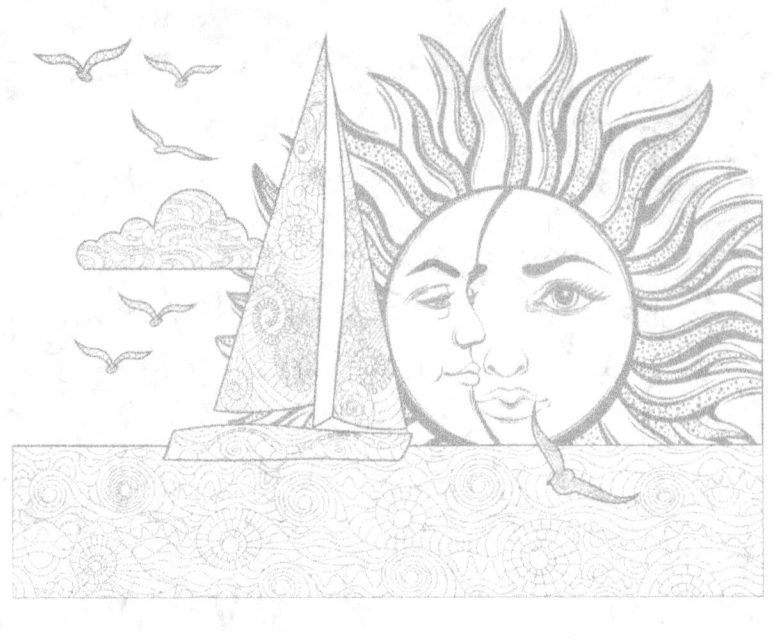

_____

_____

_____

_____

_____

The Concord Point Lighthouse was built in 1827 where the Susquehanna River meets the tidal flow of the Chesapeake Bay in Havre de Grace. It is one of the oldest lighthouses in continuous operation on the East Coast.

Havre de Grace is known as the decoy capitol of the world.

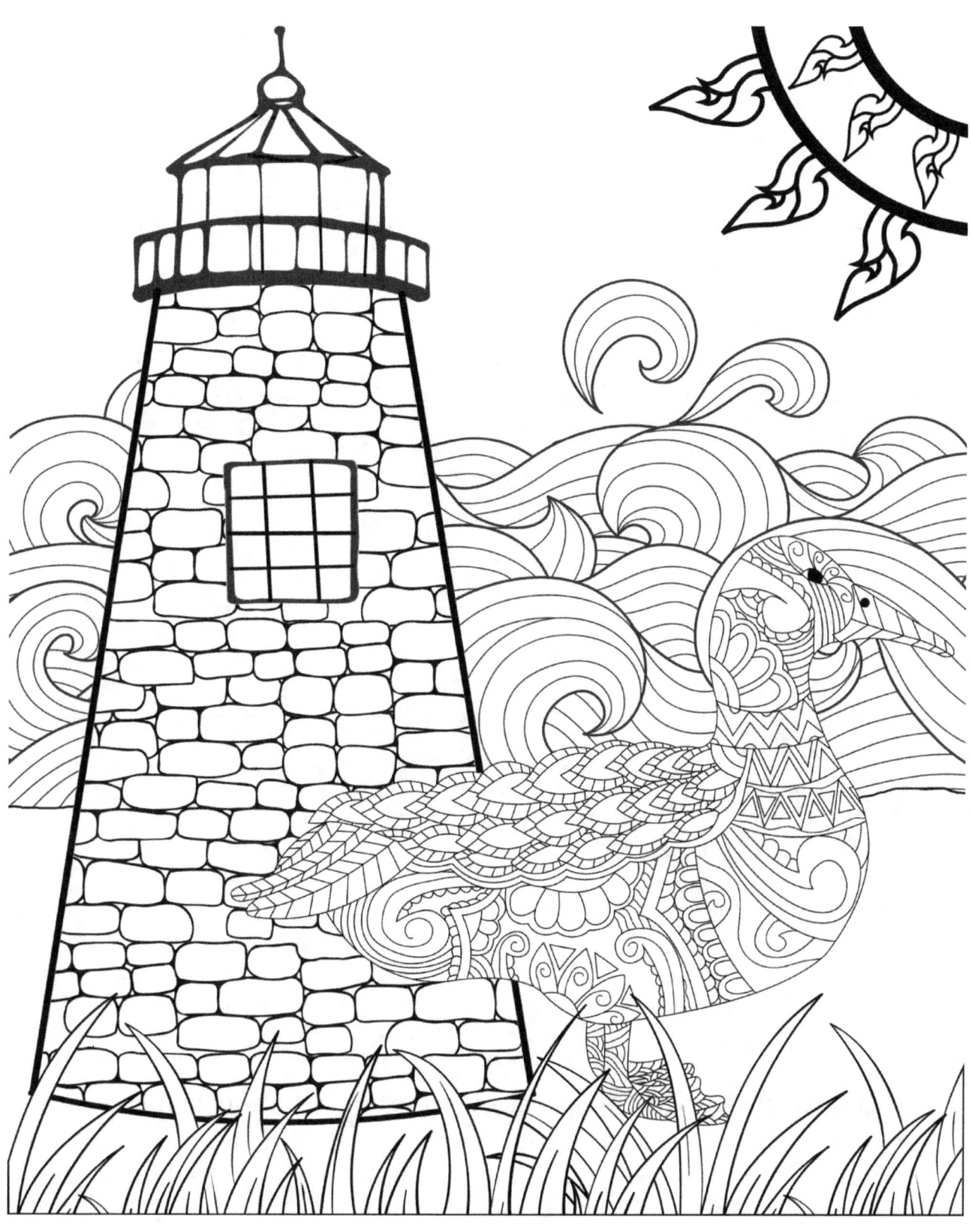

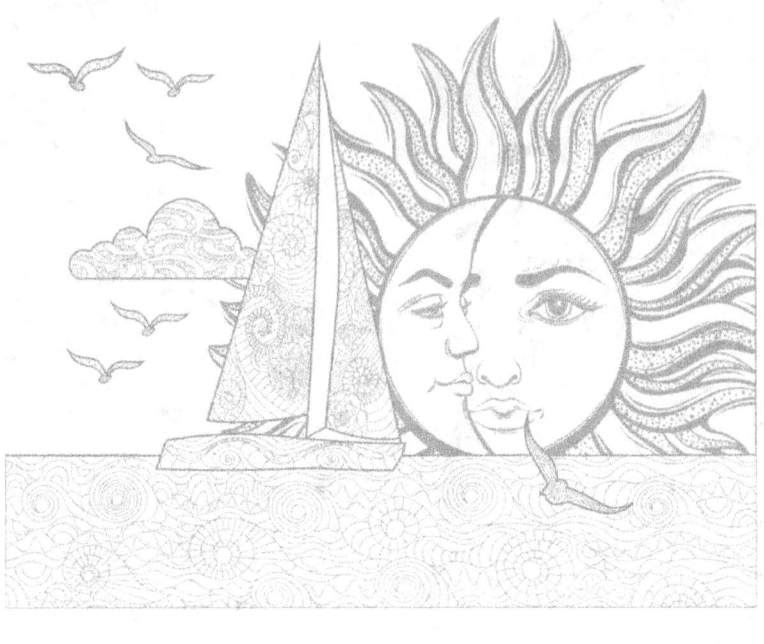

_____

_____

_____

_____

_____

Approximately 2,300 ships visit the Port of Baltimore annually.

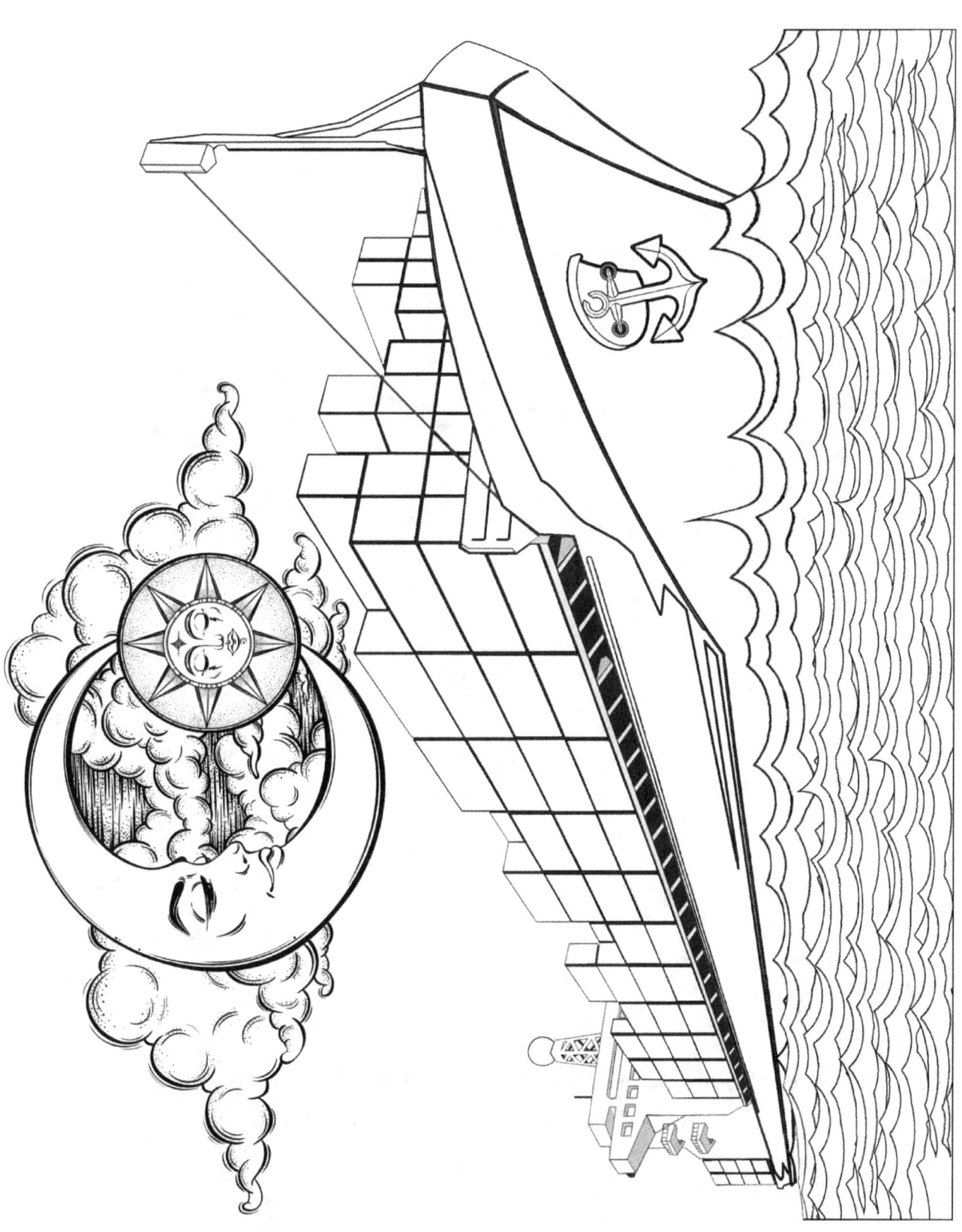

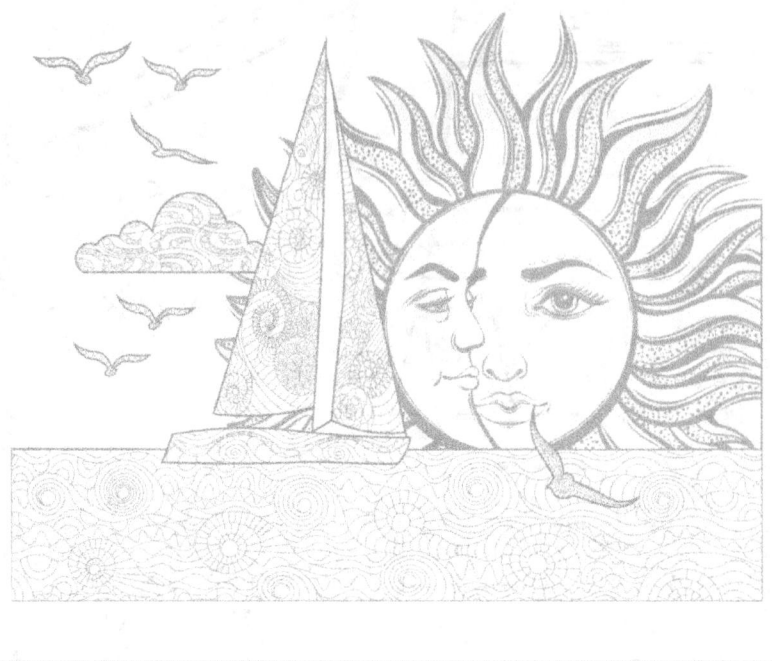

_____

_____

_____

_____

_____

Approximately 600 marinas, 40,000 in-water boat slips, and some 246 public boat ramps are located in Maryland.

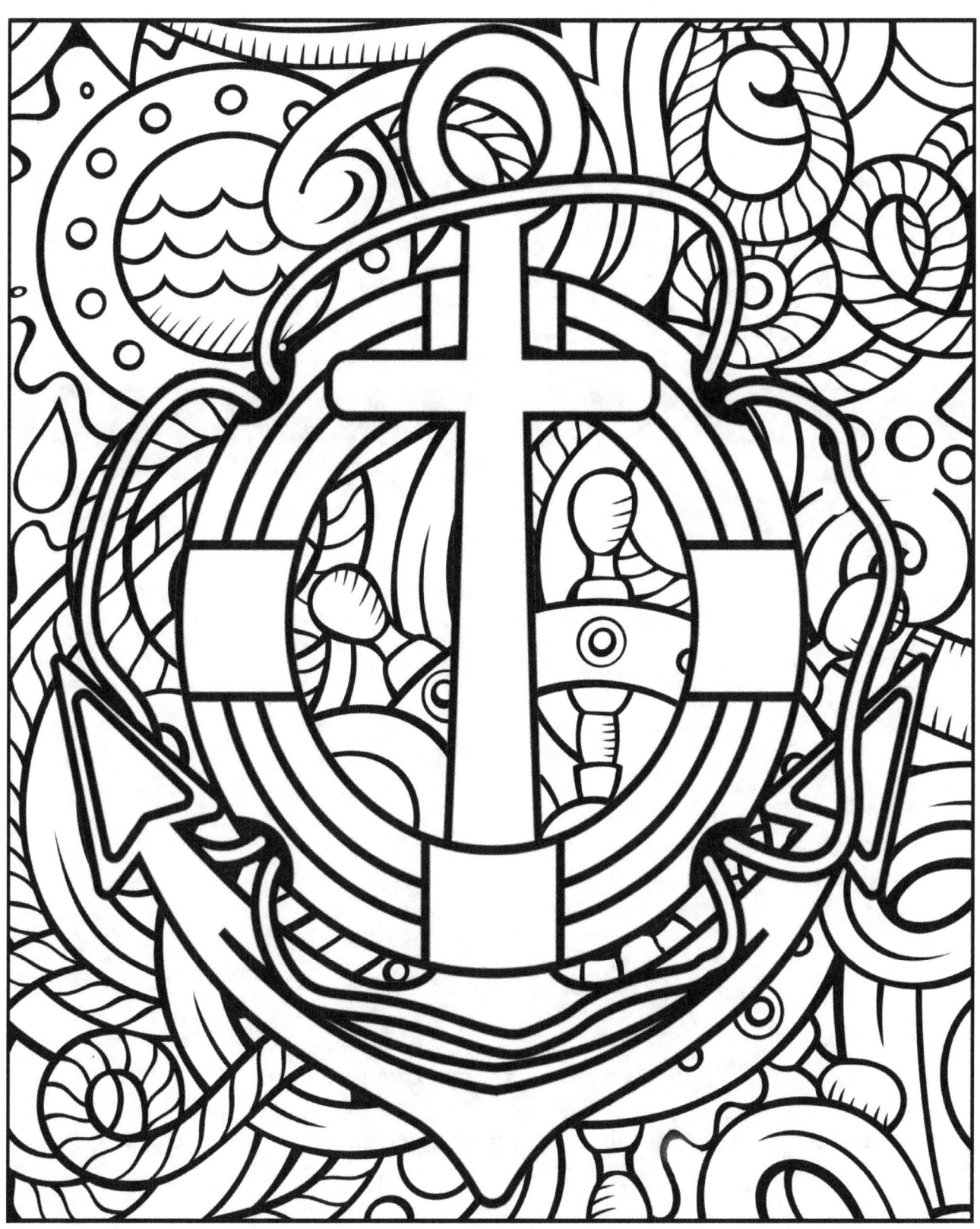

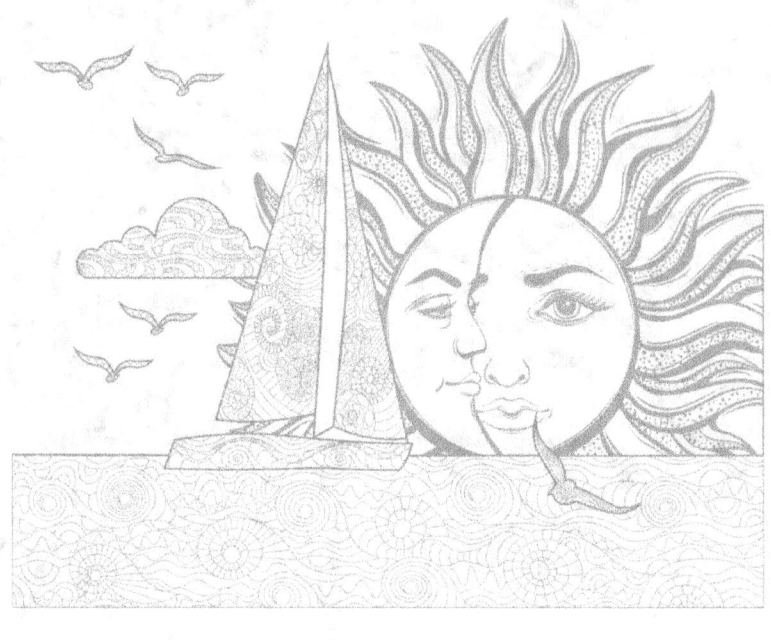

The Maryland state sport is jousting.

Modern jousting involves trying to lance three suspended rings.

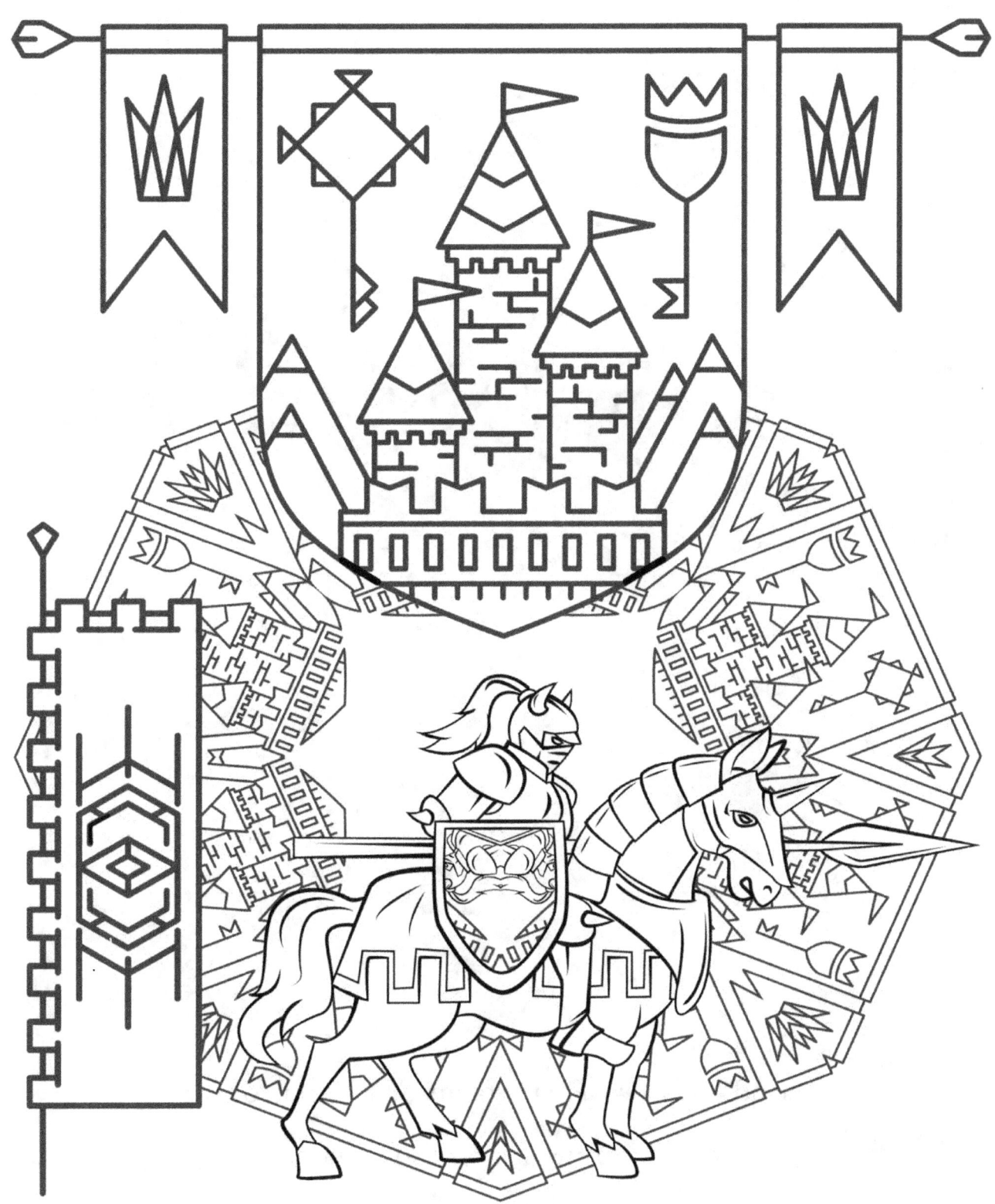

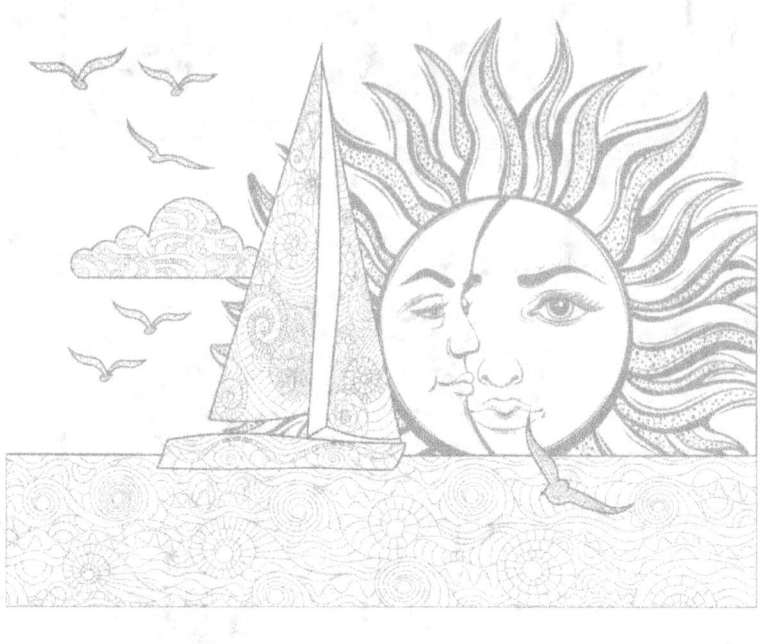

_____

_____

_____

_____

_____

Maryland forests cover approximately 2.7 million acres,

or 43% of the state's land surface..

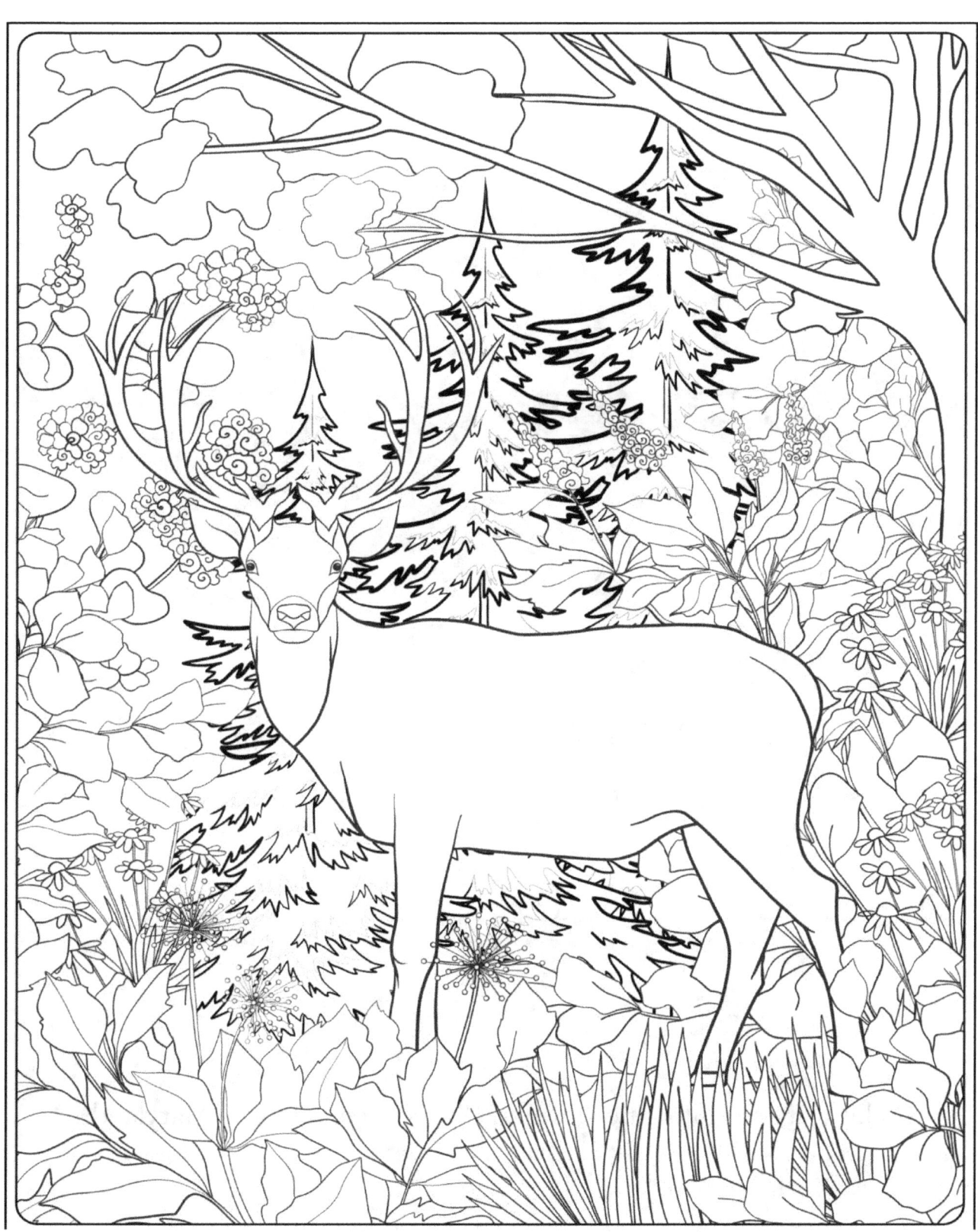

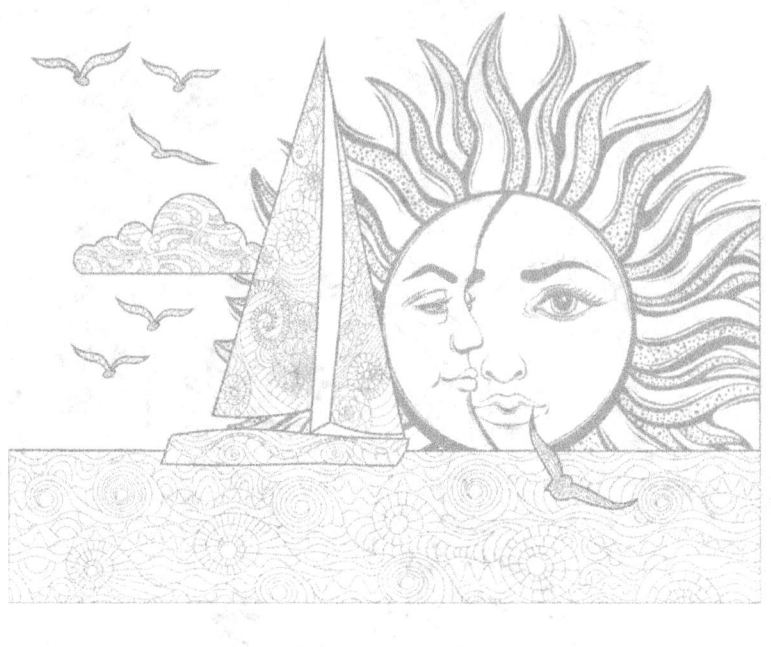

_____

_____

_____

_____

There are six authentic Covered Bridges remaining in Maryland.

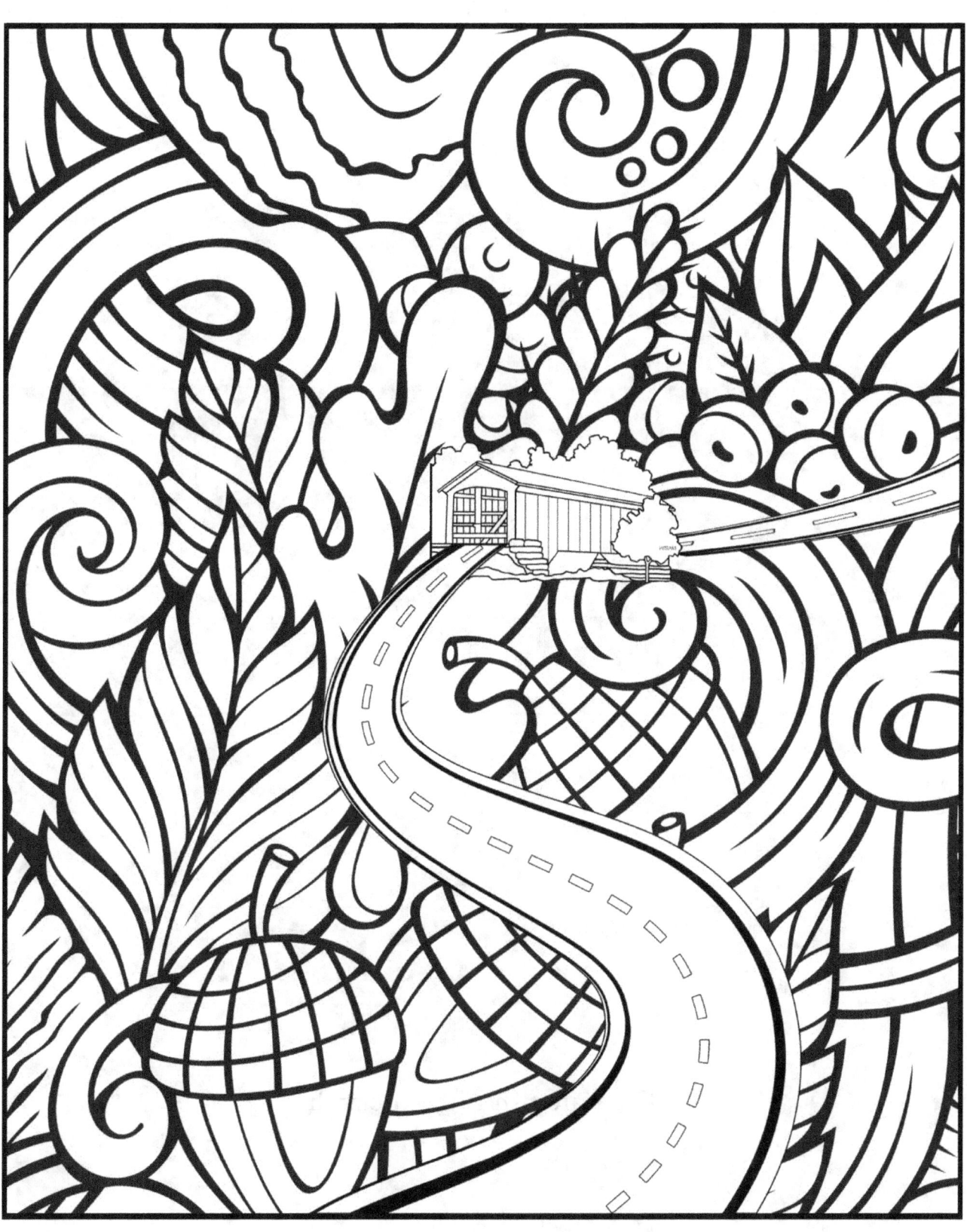

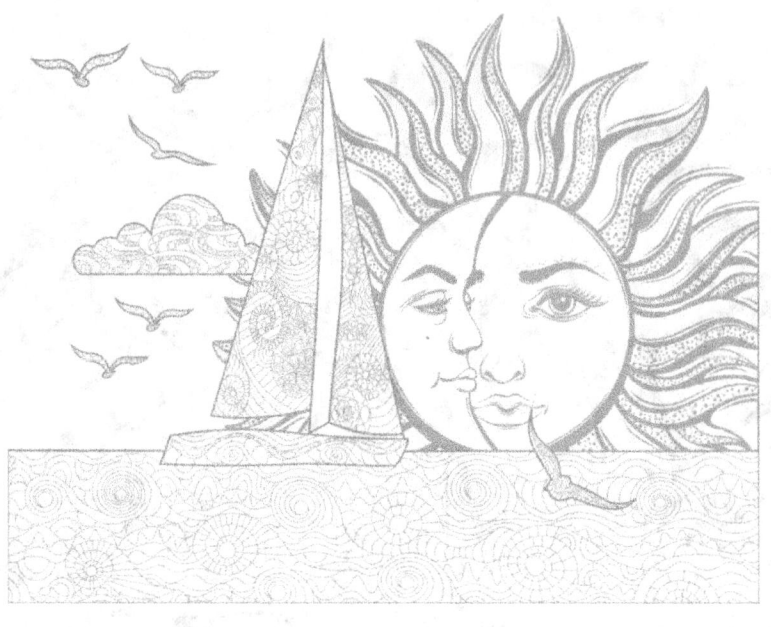

The state fish is the rockfish.

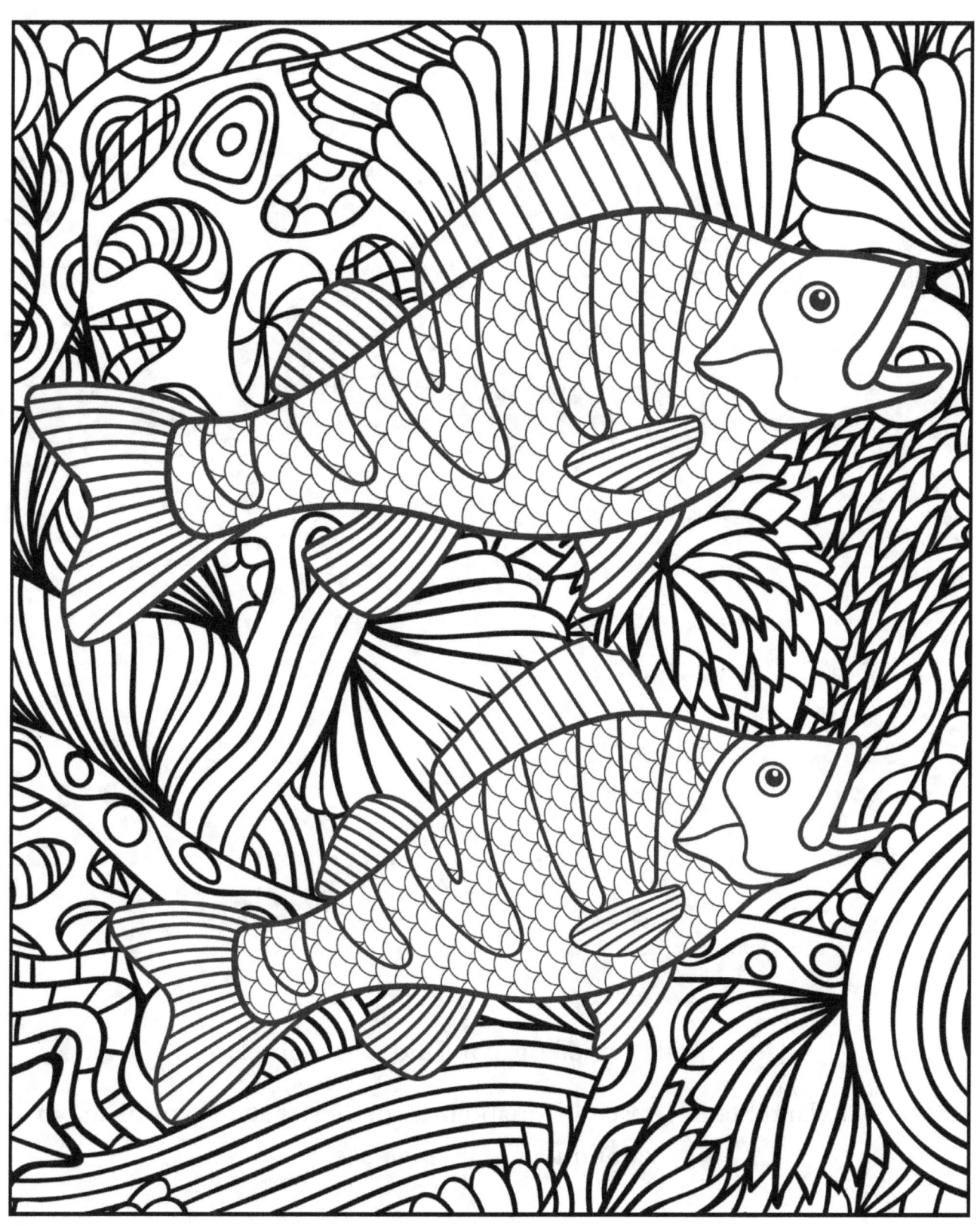

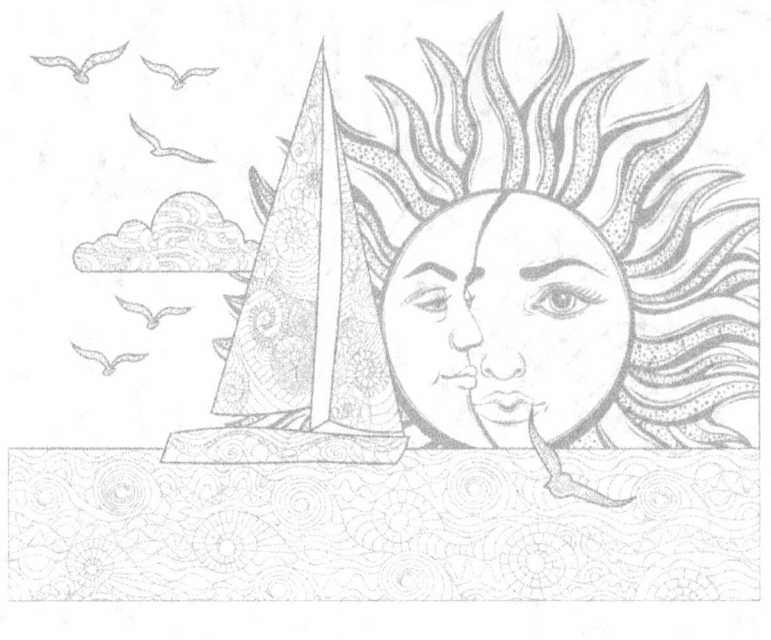

_____

_____

_____

_____

_____

The state capital of Maryland is Annapolis.

The Maryland State House in Annapolis is the oldest state capitol still in continuous legislative use.

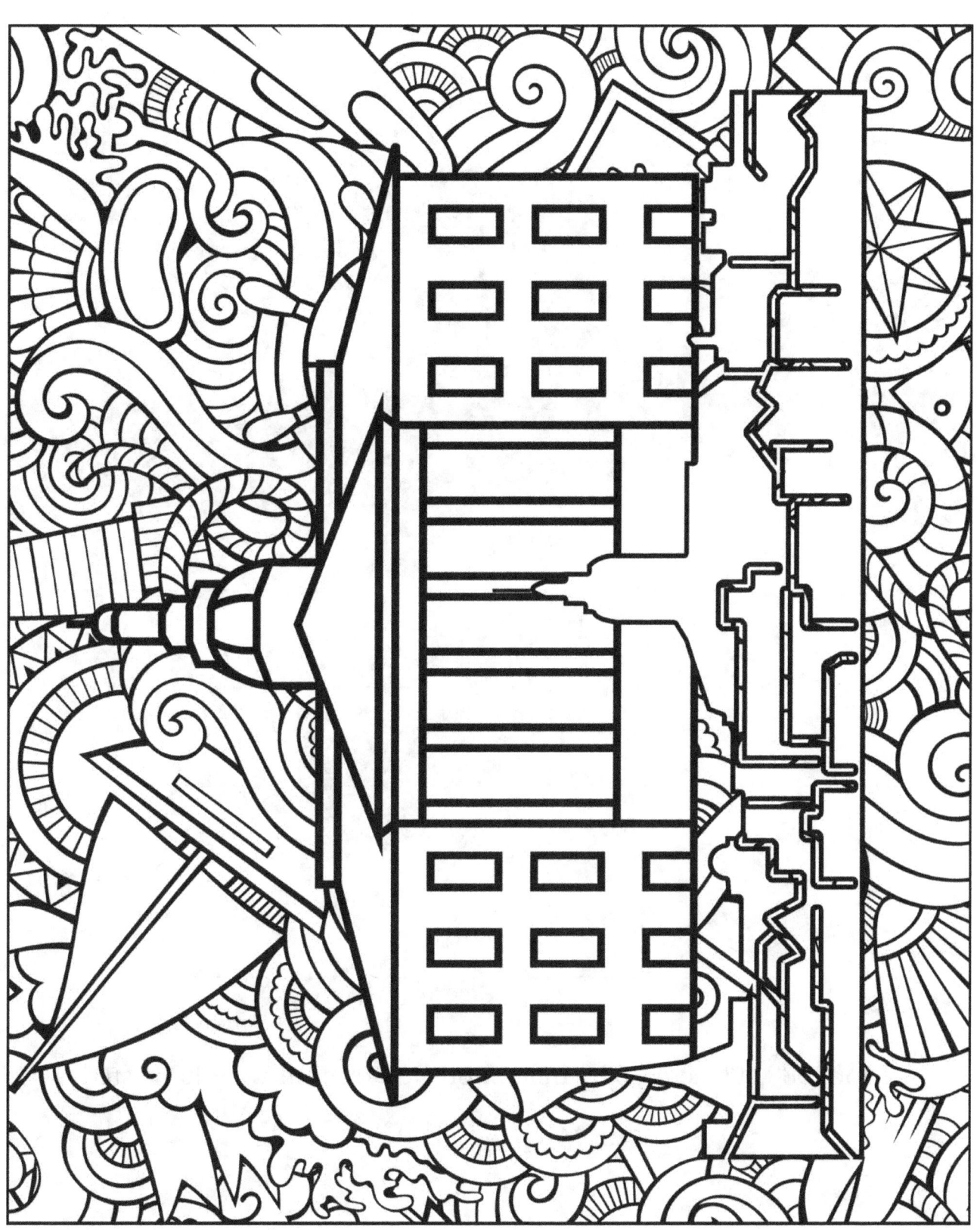

_____

_____

_____

_____

From 380,000 acres, 62.3 million bushels of corn were harvested in Maryland in 2015.

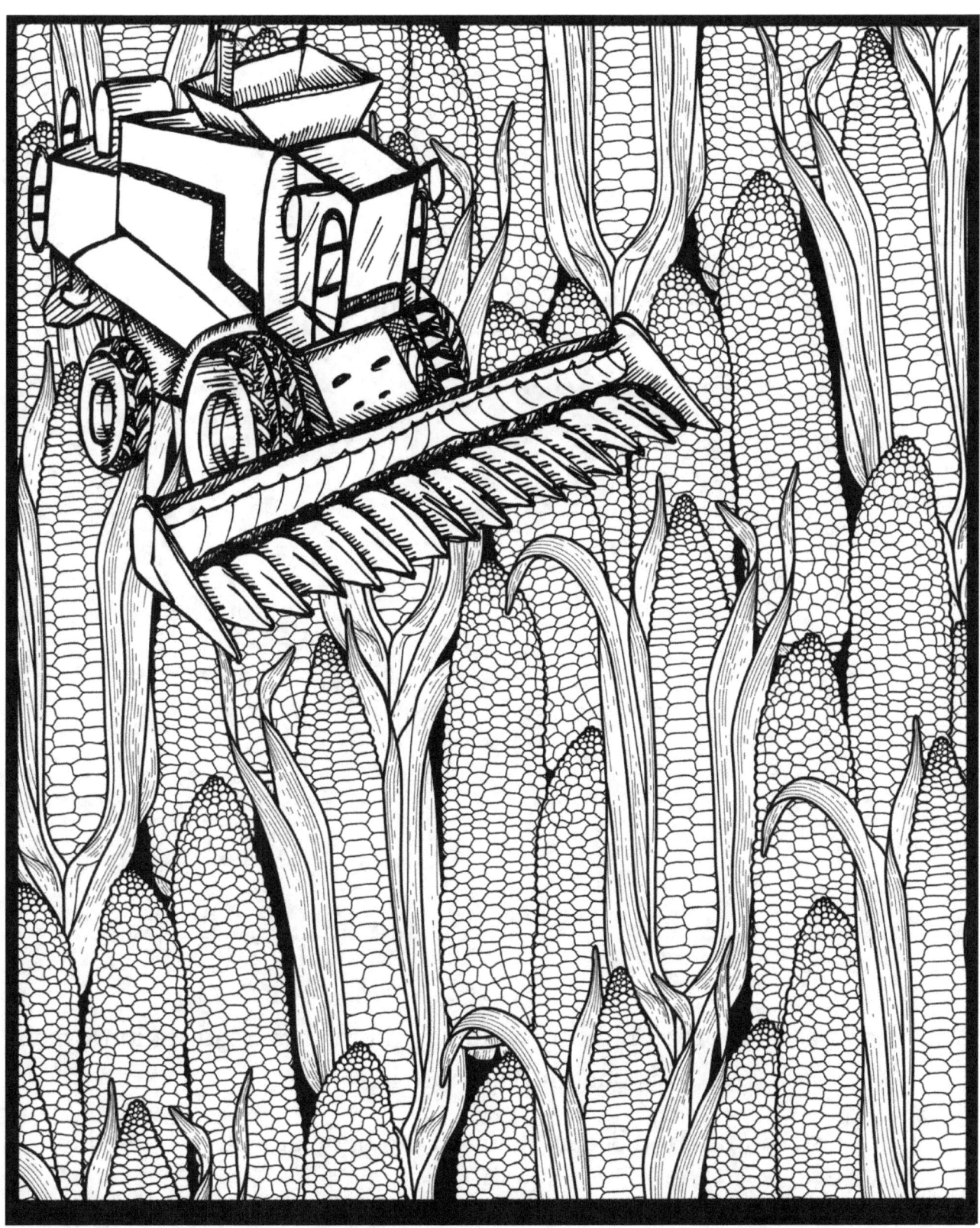

_____

_____

_____

_____

_____

Maryland has a lot of train history including the first railroad station which was built in Baltimore in 1830.

The Western Maryland Scenic Railroad is a heritage railroad based in Cumberland.

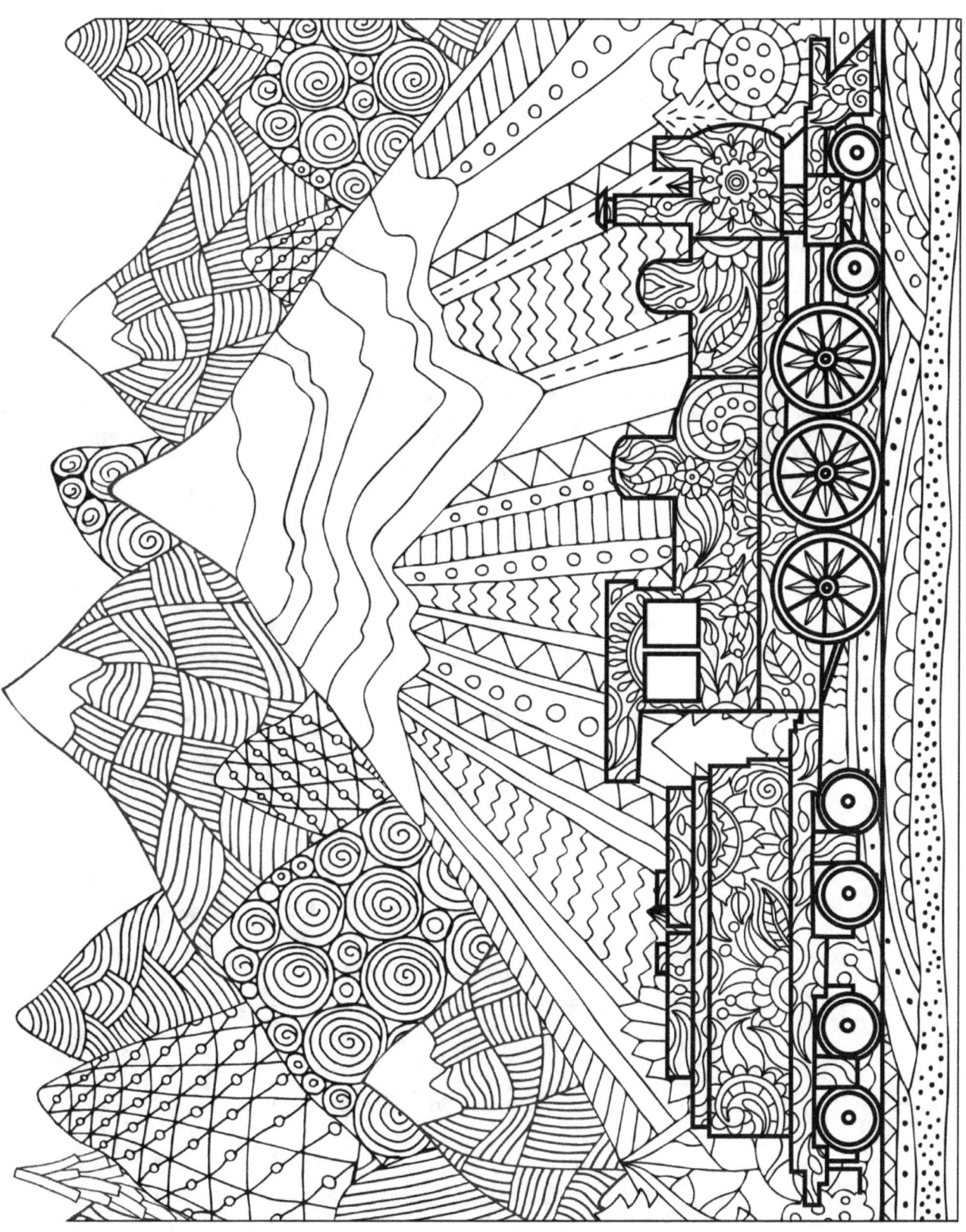

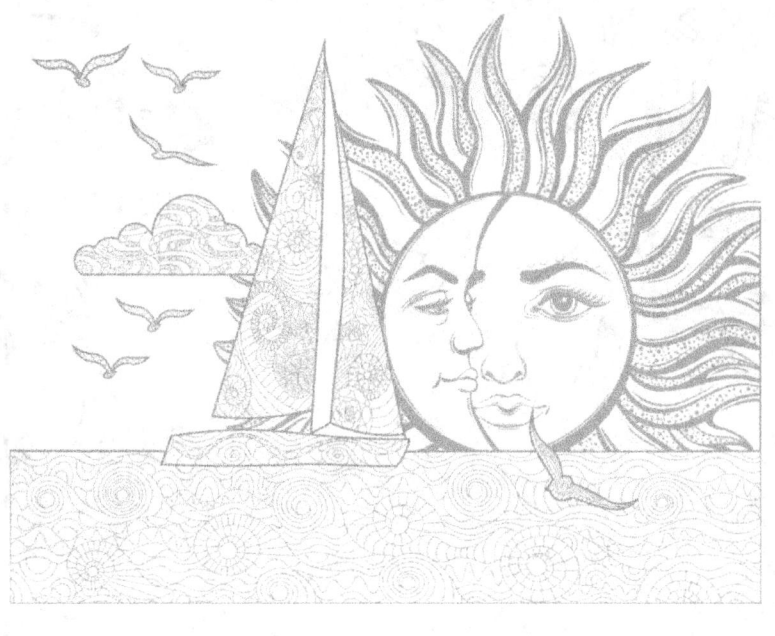

In Maryland 90 wineries offer over 420 wines.

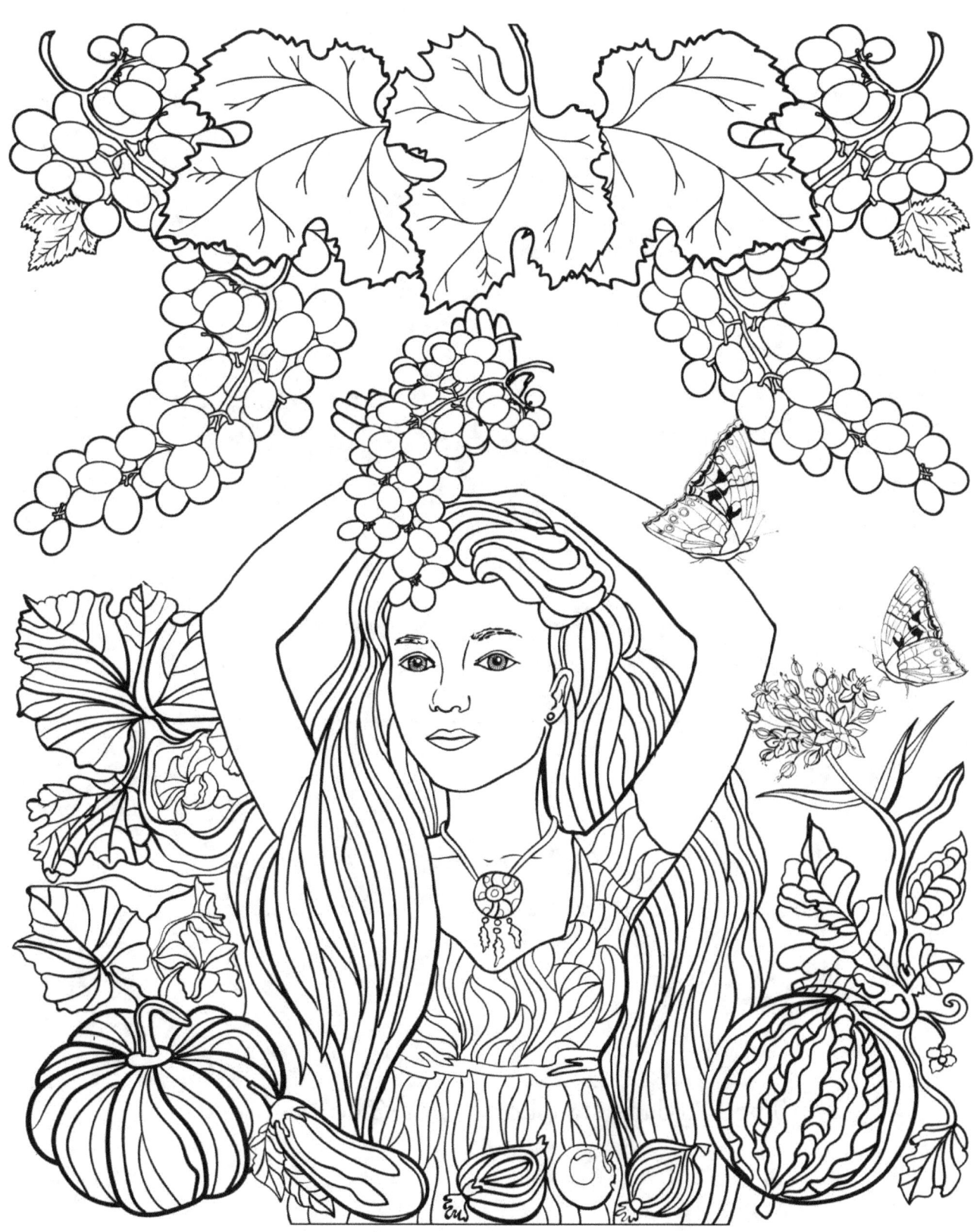

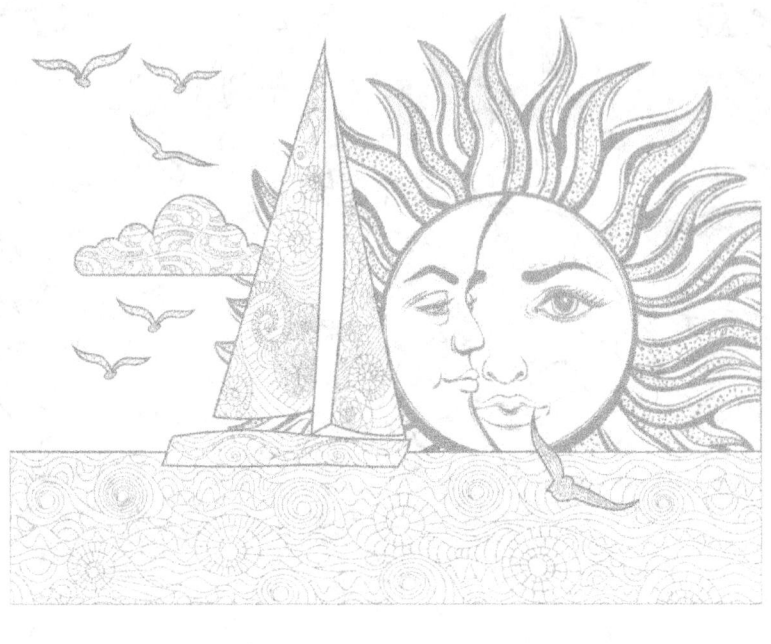

The Maryland state horse is the Thoroughbred.

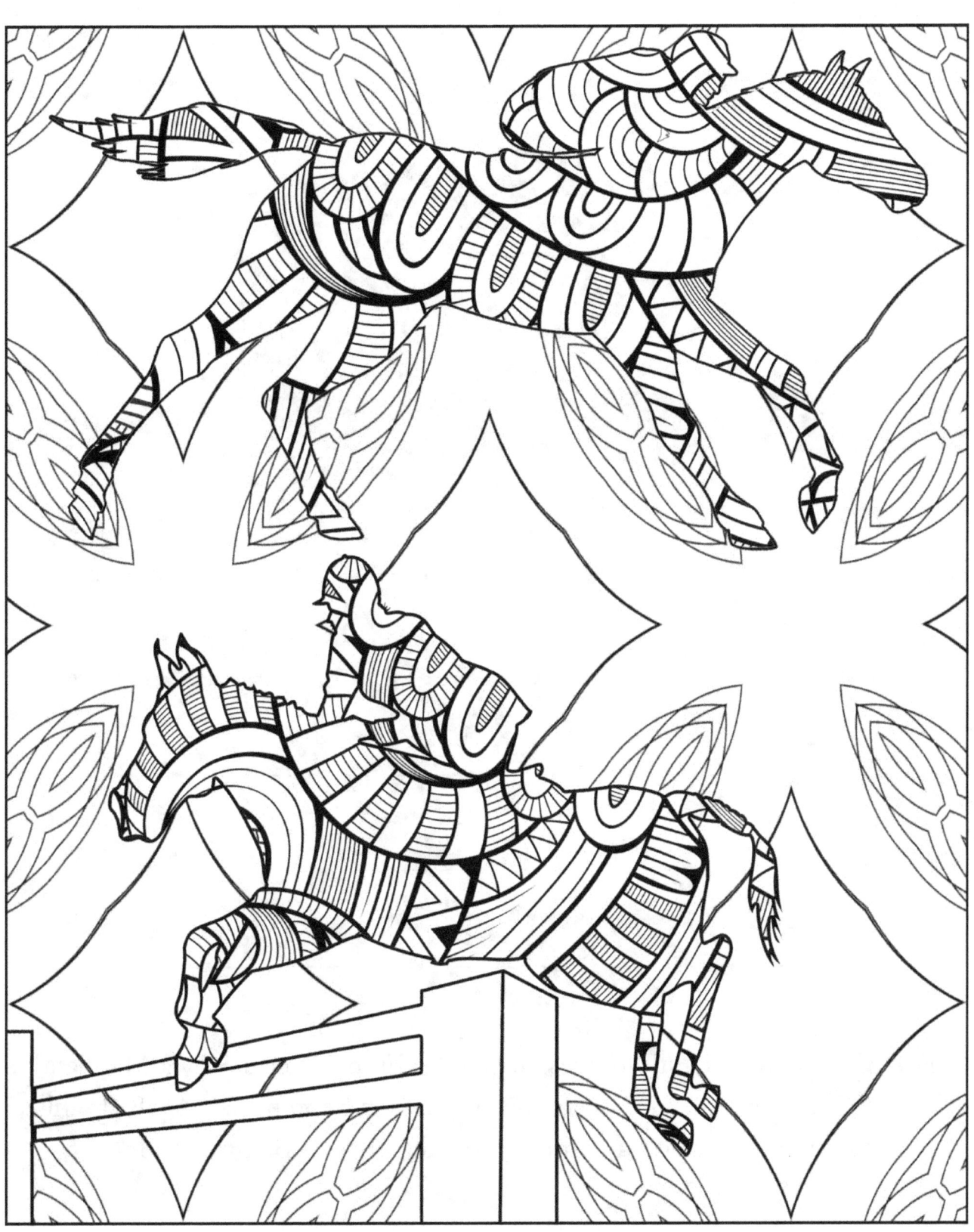

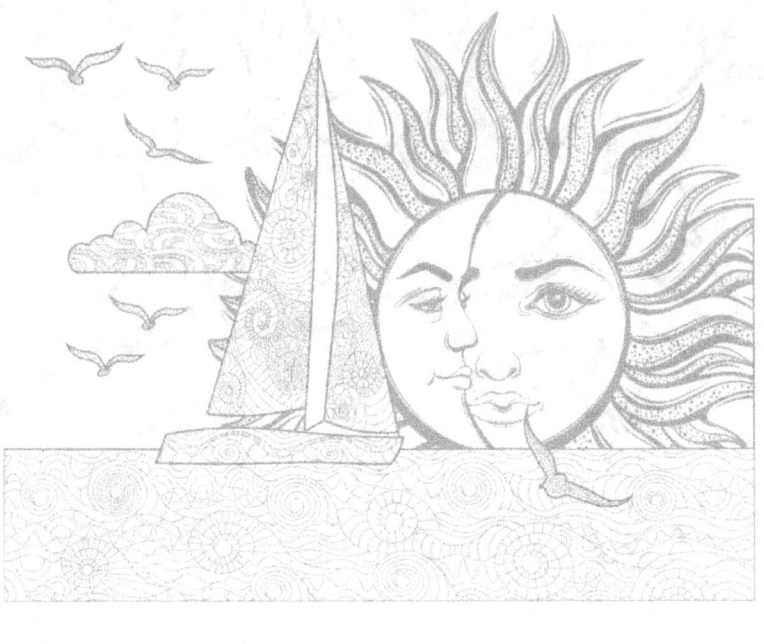

_____

_____

_____

_____

_____

America's national anthem was written by Francis Scott Key a Maryland lawyer. It is believed Key wrote the anthem on September 14, 1814 while watching the bombardment of Fort McHenry in Baltimore Harbor.

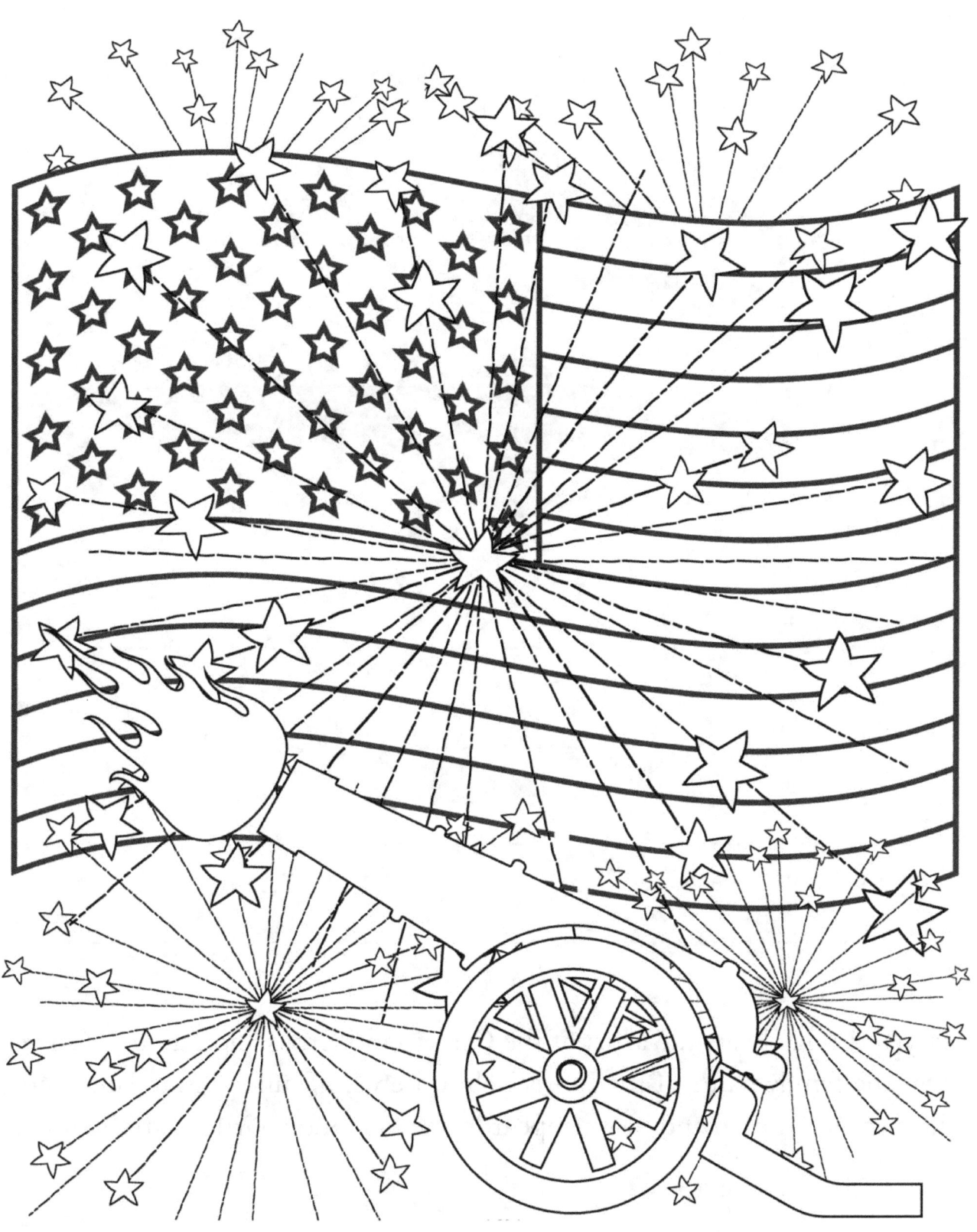

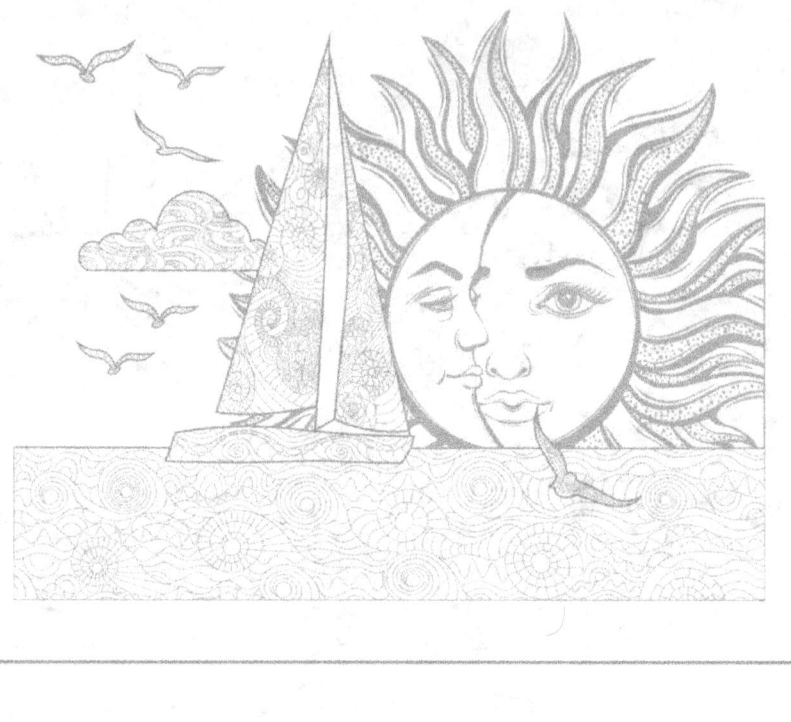

_____

_____

_____

_____

_____

Maryland's flag bears the arms of the Calvert and Crossland families. Calvert was the family name of the Lords Baltimore who founded Maryland, and their colors of gold and black appear in the first and fourth quarters of the flag.

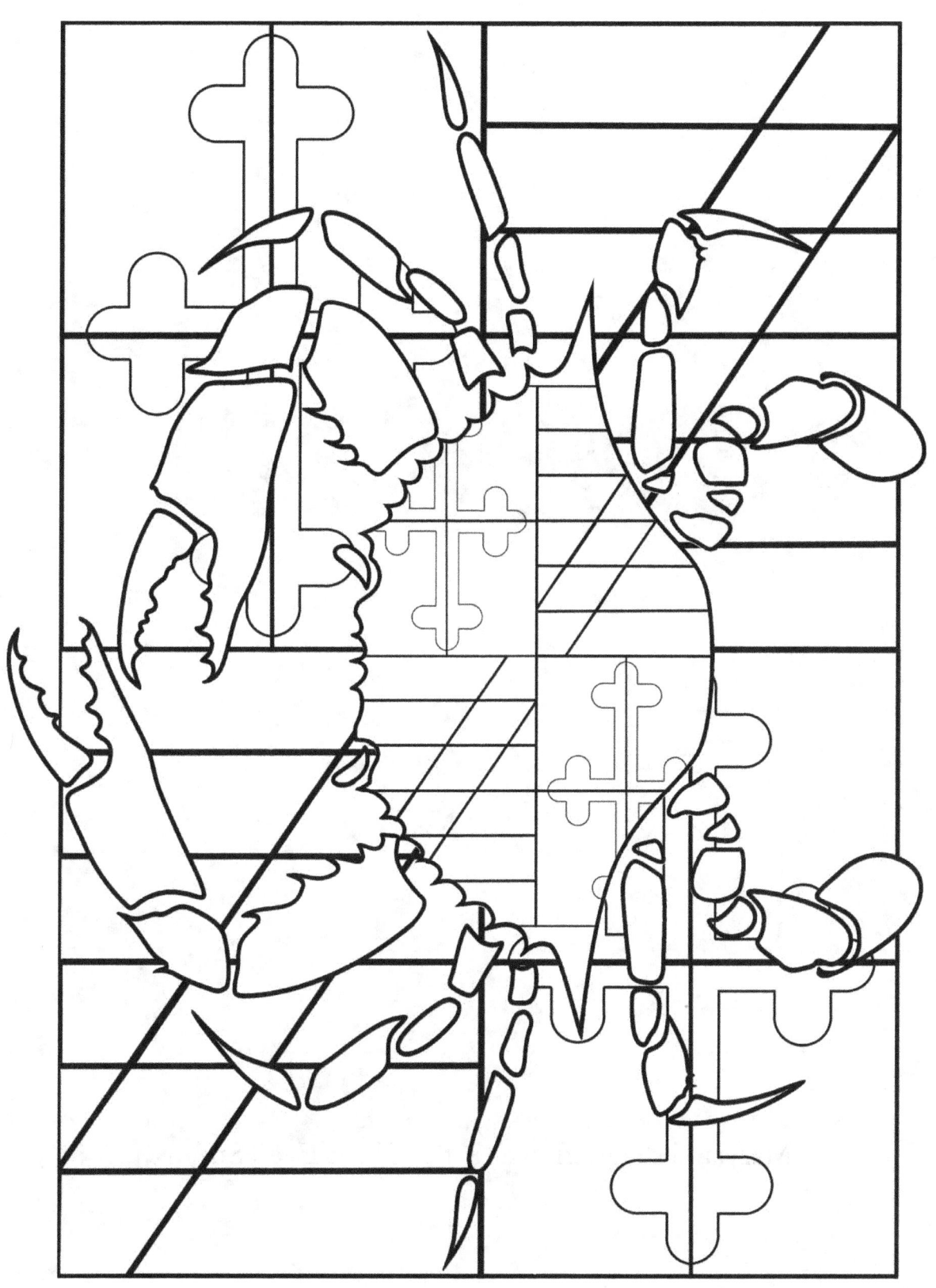

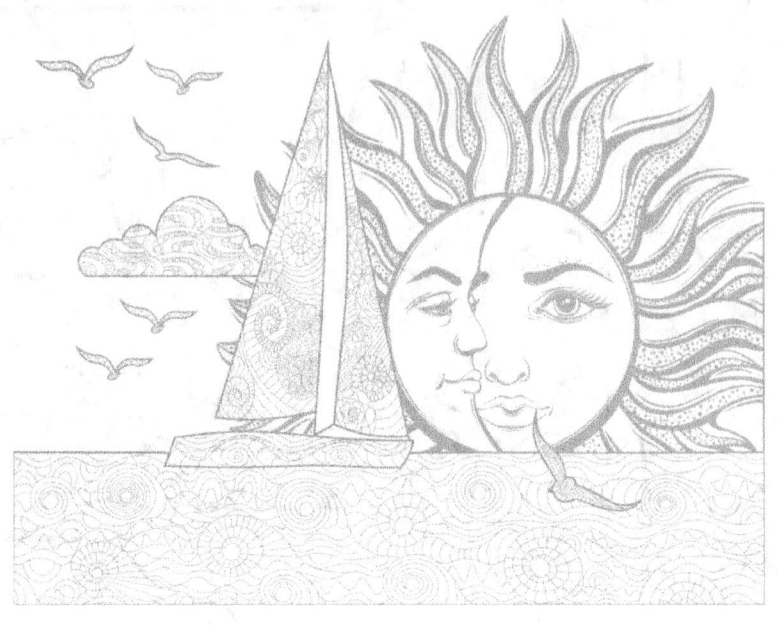

_____

_____

_____

_____

_____

Maryland's state flower is the Black-Eyed Susan.

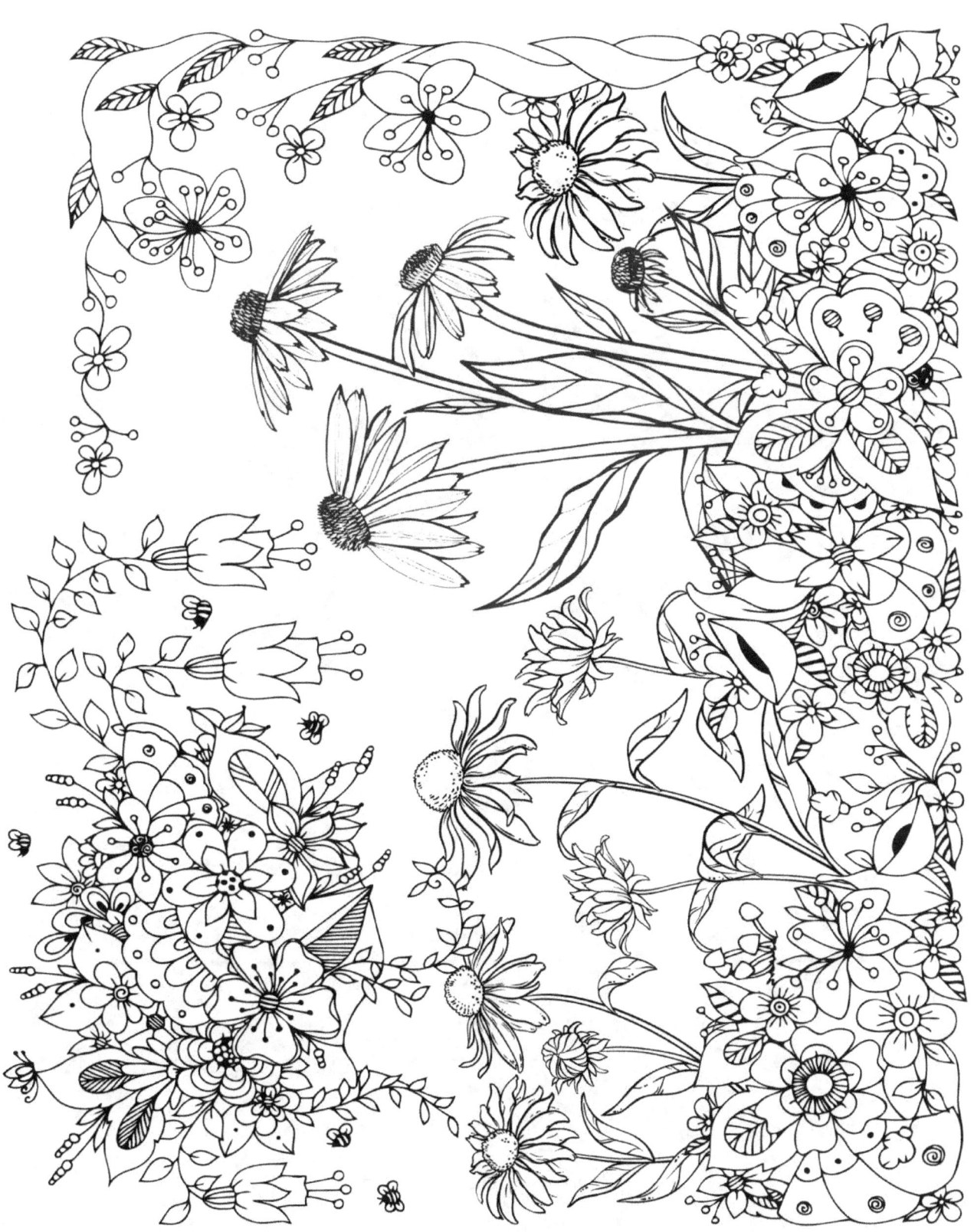

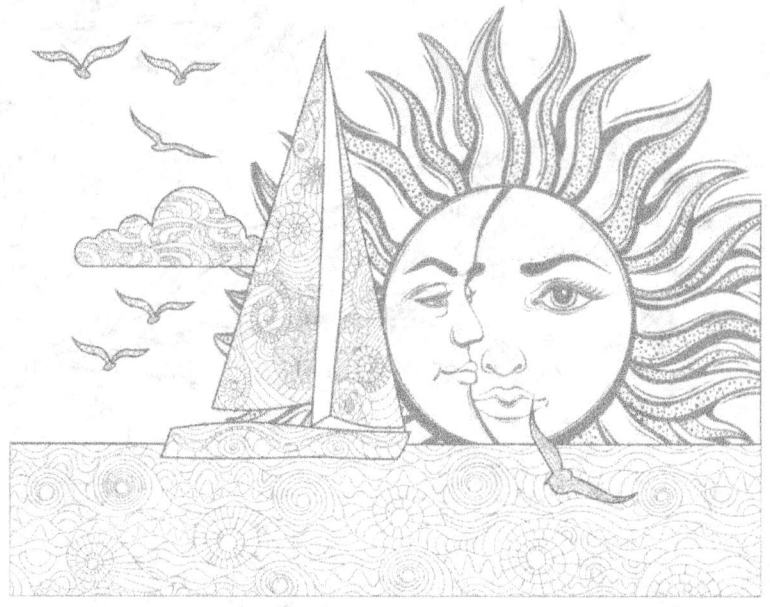

_____

_____

_____

_____

_____

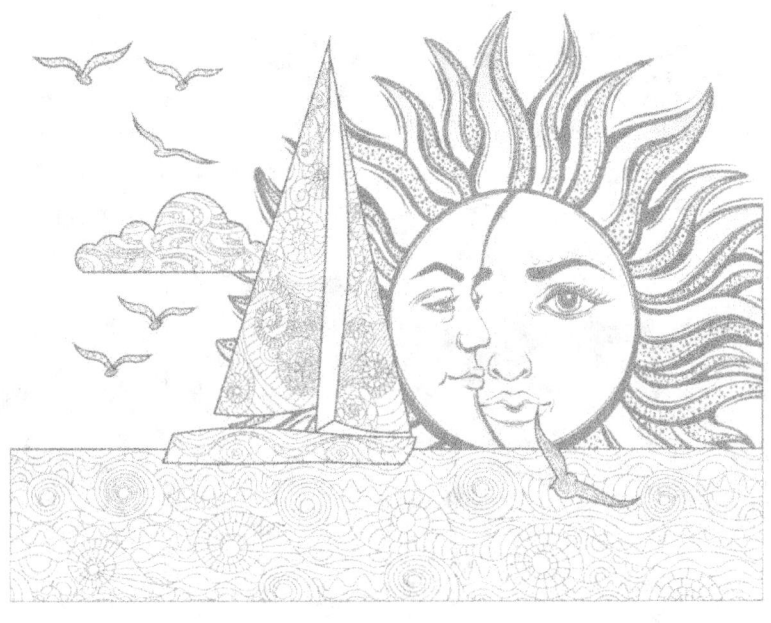

_____

_____

_____

_____

_____

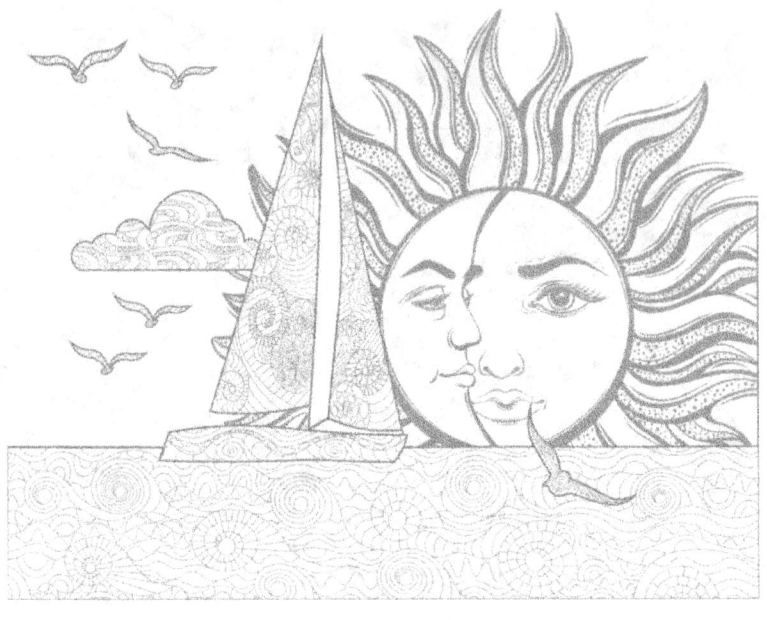

_____

_____

_____

_____

_____

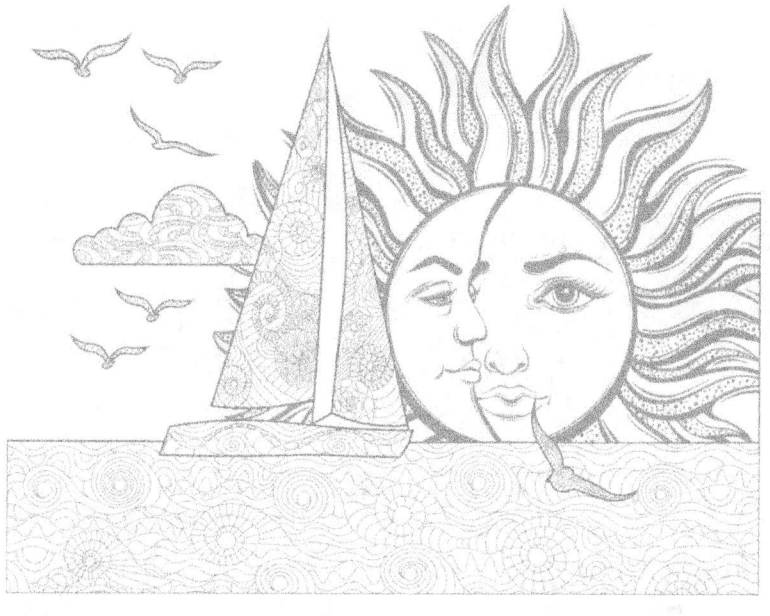

## CONNECT WITH US

We'd love to connect with you so please visit the website or like us on Facebook!

Website:

www.MyTimeToColor.com

Facebook:

http://Facebook.com/mytimetocolor

## POST A REVIEW

Your review means a lot so please consider taking a moment and posting a review on Amazon. Thanks!!

www.ingramcontent.com/pod-product-compliance
Lightning Source LLC
Chambersburg PA
CBHW081208180526
45170CB00006B/2254